PORT OF TILBURY
IN THE 60s AND 70s

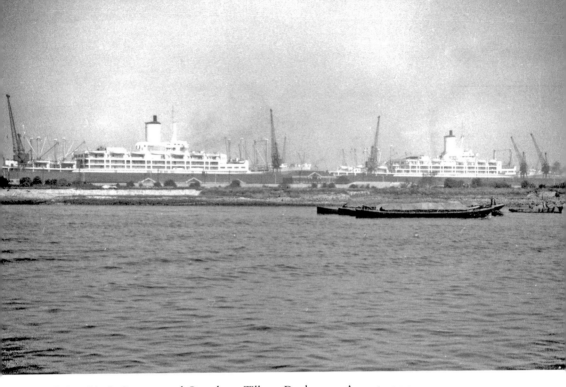

Orient Line's *Oronsay* and *Orcades* at Tilbury Dock on 14 August 1954.

PORT OF TILBURY
IN THE 60s AND 70s

CAMPBELL McCUTCHEON

AMBERLEY

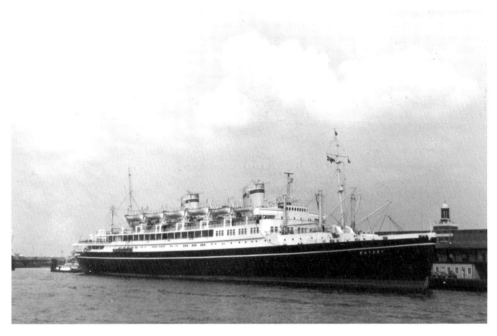

MV Batory (14,287grt, built 1936) at Tilbury, 30 August 1967.

First published 2013

Amberley Publishing
The Hill, Stroud
Gloucestershire, GL5 4EP

www.amberley-books.com

British Library Cataloguing in Publication Data.
A catalogue record for this book is available from the British Library.

ISBN 978 1 4456 2279 8
E-BOOK ISBN 978 1 4456 2293 4

Typesetting and Origination by Amberley Publishing.
Printed in Great Britain.

Contents

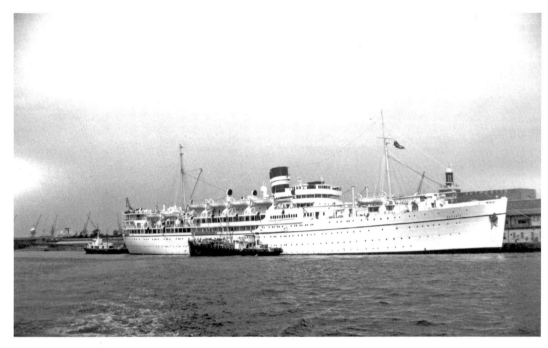

Being bunkered while at the Stage is the British India liner *Devonia* on 29 July 1964.

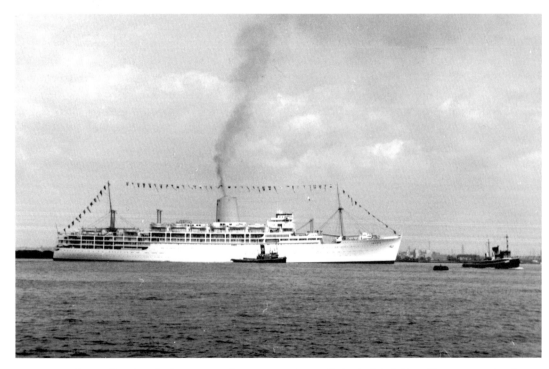

Dressed overall and at the beginning of a voyage to Australia is the P&O liner *Iberia* on 22 April 1967.

Introduction

Tilbury, located on the lower Thames, is now the closest deepwater dock to London itself. Located some twenty-five miles down river from the Pool of London, that ancient heart of the city, it was established in what had been marshland, at a meander in the river, which also narrowed to some 800 yards between Gravesend and Tilbury. Tilbury itself was the site of a Tudor fort, built to protect the entry to London by sea and made famous by Queen Elizabeth, who made her most famous speech close by on the eve of the expected invasion by the Spanish Armada fleet in 1588. The fort itself is one of the best preserved of this type of fort in the world.

With the coming of the railways, it was no longer necessary to have the docks close to the centre of London and, with expansion beyond the upper docks necessary, a new dock was planned at Tilbury in the 1880s. Receiving an Act of Parliament in the spring of 1882, work began on the new docks at Tilbury almost immediately Royal Assent was granted. Four years later, on 17 April 1886 the SS *Glenfruin* opened the Port of Tilbury. The dock system was composed of two dry docks, located between a tidal basin and main dock, as well as three branches, named East, Central and West Branch docks.

In 1909, the dock system at Tilbury became part of the new Port of London Authority's estate, along with the major docks closer to London. After the end of the First World War, expansion took place at Tilbury, with a new 1,000ft lock being built to accommodate the largest liners and cargo ships of the time, as well as a third dry dock. With the closure of the upriver docks between the 1960s and 1980s, Tilbury was extended and, between 1963 and 1966, a new branch dock was built. It ran north from the Main Dock for almost a mile. With this expansion, the tidal dock was closed and filled in and a new granary built at Northfleet Hope in 1969.

A revolution took place in 1970, and one that was to change the shipping world for ever; the first container ship called in that year and from then on, the traditional general cargo ship was doomed. The next decade was to see the end of many traditional shipping lines, which simply could not afford the investment in new container vessels and the infrastructure required for them to operate. In 1992, Tilbury was privatized and is now in the ownership of Forth Ports, which has overseen expansion of the

facilities and, at the time of writing, a new project on Tilbury marshes hopes to secure employment for over 1,000 people with the construction of new storage and distribution facilities. The port's access to London, and the rest of the UK, via the Dartford crossings and the M25 make it an important facility and it is one of Britian's busiest ports today.

Tilbury itself is also home to the London Cruise Terminal, but passenger ships have been using the port since the advent of the railways. With the coming of the London, Tilbury & Southend Railway in 1854, ships could call next to Tilbury Riverside station and disgorge passengers who could then reach central London a few hours before vessels that called into the upper river. It was decided after the First World War that a new terminal and landing stage would be built to accommodate passenger ships calling for London and the world famous Tilbury Landing Stage was built. It was used by the large liners calling at London as well as the ferries crossing the river to Gravesend and also by ferries for Europe too. The Stage floats and can rise or fall over twenty feet, depending on the tide. Officially opened in 1930, the Stage has seen many famous vessels call, from the giant P&O and Orient liners to the *Empire Windrush* in 1948, as well as more modern cruise ships, which do not have to navigate the tricky approaches to central London.

Within these pages we see a port in transition, from general cargo to container and from passenger to cruise traveller. The photos, all taken in a period of some thirty years, take us on a journey not only of time but also of transition. We can see the loss of the passenger shipping that made Tilbury Landing Stage important, while observing the growth of cruise traffic at the same time as viewing the loss of shipping lines that once called. Names such as Glen Line, Shaw Savill, Royal Mail Lines, British India Steam Navigation Co., Orient Line, Swedish Lloyd, Aznar and Union Castle to name a few, have all come and gone. Some, such as Fred. Olsen, still call at the Stage. We also see the growth of new shipping lines such as OCL and Royal Caribbean. Tilbury has an assured future and can look proudly not only at its past but also into its future as London's gateway port.

Chapter One

The Landing Stage

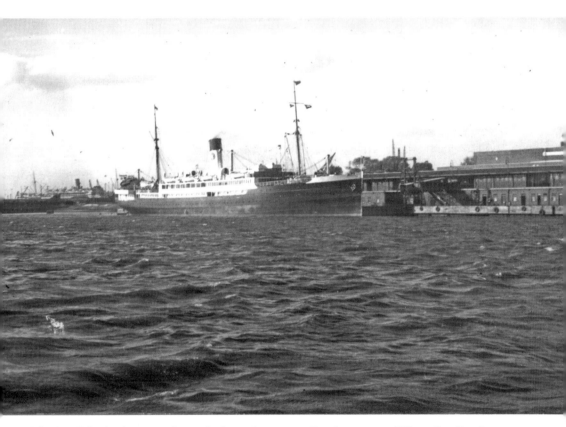

The Swedish Lloyd steamer *Suecia* is shown here on 15 October 1949 at Tilbury Landing Stage. The *Suecia* sailed from Gothenburg to London. Built in 1929, with her sister *Britannia*, she sailed for Swedish Lloyd until 1966, when she was sold to the Greek Hellenic Mediterranean Lines and was scrapped in 1973 as the *Isthmia*.

The ex-Nelson Lines MV *Highland Princess* was also built in 1929, in Belfast, for the South American routes from London. As well as passengers, the ship could carry huge quantities of frozen beef from Argentina and Brazil. The Nelson Line itself was founded by the Nelson brothers, Irish butchers who had made a small fortune shipping cattle and beef from Ireland to Britain. By 1949, the Nelson Line was very much a part of the Royal Mail Lines group and the ship is shown in RML livery here on 14 August 1954.

Built in 1950, the Argentinian steamer *17 de Octubre* (12,653grt) was the third new ship for the Compañia Argentina de Navegación Dodero, with the *Presidente Peron* and *Eva Peron* sailing in 1949 and earlier in 1950 respectively. This new line sailed from Buenos Aires to Vigo, Amsterdam and London. Photographed on 22 June 1955, the ship was soon to be renamed *Libertad* after the fall of the Peron government in September of that year.

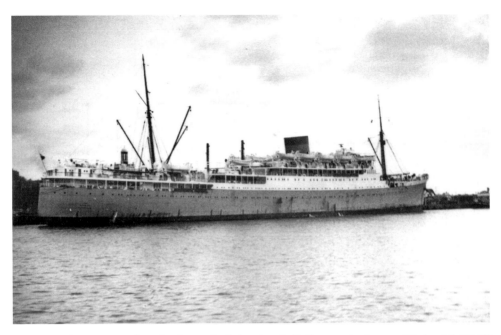

Union Castle Line's *Durban Castle* was built in 1938 in Belfast, at the famous Harland & Wolff yard, and is shown here on 11 September 1955.

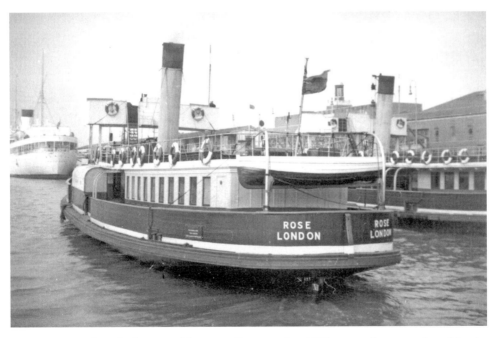

For centuries a ferry had operated between Gravesend and Tilbury, and was purchased by the railway company. By 1948, the ferries had passed into the ownership of the British Transport Commission and *Rose*, built in 1901, is almost ready to arrive at the Stage on 11 September 1956. Another of the ferries is already berthed.

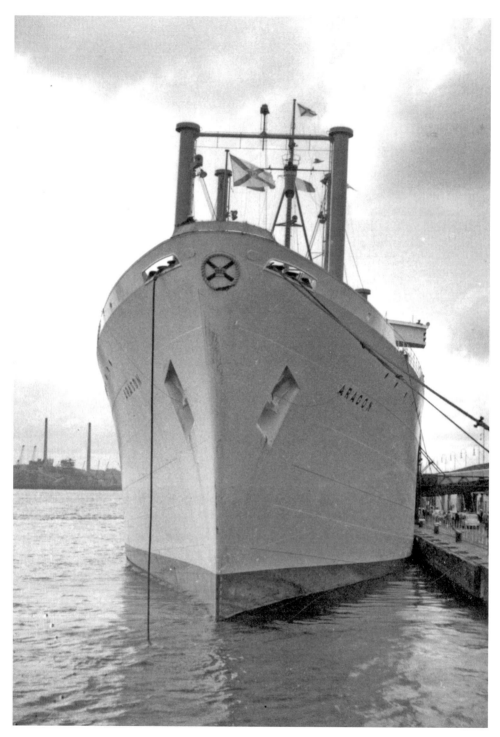

Brand new in 1960, and berthed at the Stage on 17 September that year is the 20,362grt MV *Aragon* of the Royal Mail Lines. Transferred to Shaw Savill & Albion, she was then resold to a Norwegian shipowner in 1971 to become the *Hoegh Traveller*, a car carrier.

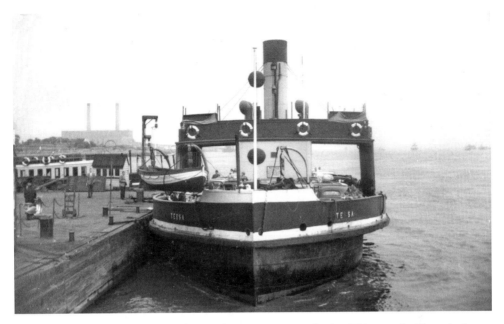

In 1924, the LMS railway had built at Lytham two new car ferries. This one, the *Tessa*, is shown on 6 August 1960, five years before she was scrapped. Introduced in October 1924, it was the building of the Dartford Tunnel that saw the demise of the car ferries. In the left background is the Tilbury Power Station. Oil-fired, it was opened in 1956 and mothballed in 1981. Partly demolished in 1999, parts of the now-listed building still remain.

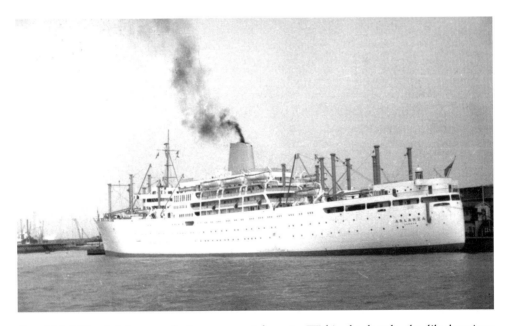

Royal Mail Lines' *Arlanza* at the Stage on 22 July 1961. Within the decade, she, like her sister *Aragon*, had become a car carrier. Within the space of eleven years, the almost brand-new ship had become redundant as a passenger/cargo liner due to the advent of air travel.

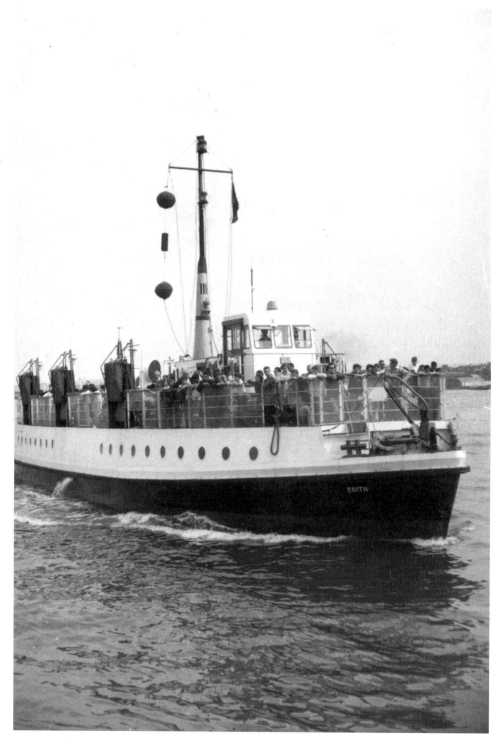

In 1960-61, new diesel ferries were built to replace the almost sixty-year-old veterans of the Gravesend-Tilbury crossing. In mid-river is the MV *Edith* on 12 August 1961.

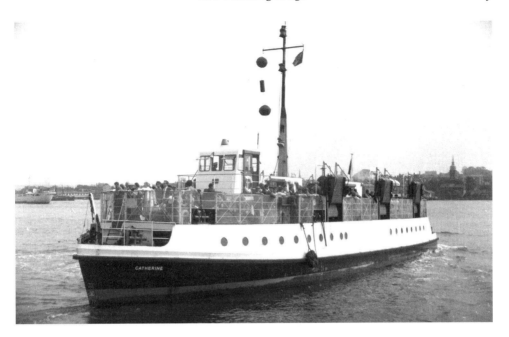

On the same day is the *Catherine*, of 214grt, off Tilbury with a heavy load of passengers.

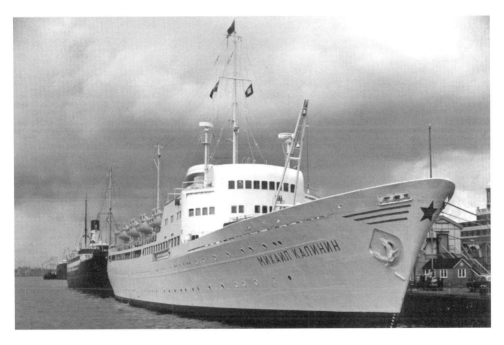

The Russian MV *Mikhail Kalinin* (4,722grt, built 1958) at Tilbury on 17 August 1963. Astern is a Swedish Lloyd steamer. Russian vessels were frequent callers at Tilbury, as we shall see throughout this book. There were nineteen ships in the Mikhail Kalinin-class of vessels, built between 1958 and 1972. Alternating between deep-sea voyage liner routes and cruising, the Russian ships provided much-needed Western currency.

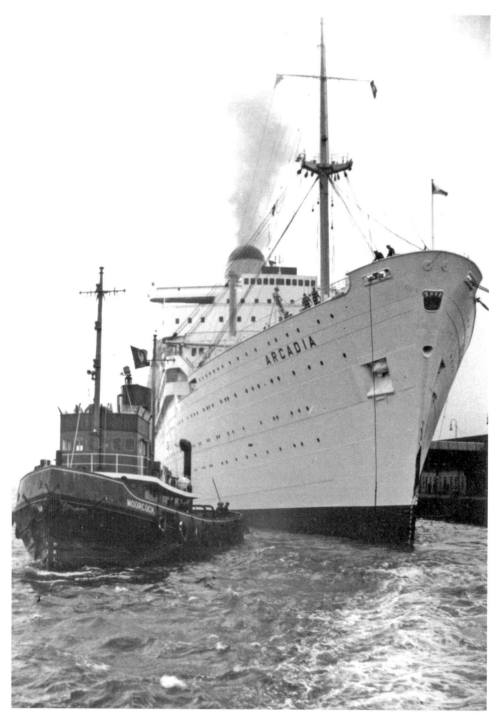

P&O's *Arcadia*, built on the Clyde at John Brown's in 1953, leaves Tilbury Stage on 21 August 1963, assisted by the tug *Moorcock* (built 1959, 272grt). Entering service in 1954 on the Australian route, *Arcadia* was scrapped in 1979, leaving *Canberra* to soldier on into the 1980s as one of the last British passenger liners.

Mimie and *Rose* at the Stage, 8 May 1964. *Mimie* was built as a car ferry in 1927 for the LMS railway. On 31 December 1964, she stopped operating the service, due to the 1963 opening of the Dartford Tunnel.

From 1939 to 1975, the Greek Line operated a passenger service, and called at London on transatlantic voyages. Shown here is their *Arkadia*, which had had a long career as the *Monarch of Bermuda*, *New Australia* and *Arkadia*. Built in 1931, she served in both World War Two and in the Korean War before becoming *Arkadia* in 1958. In November 1966, she was laid up in the Fal and then sold for scrapping, arriving in Valencia in December 1966. Two Sun tugs are ready to pull her away from the Stage on 26 July 1964.

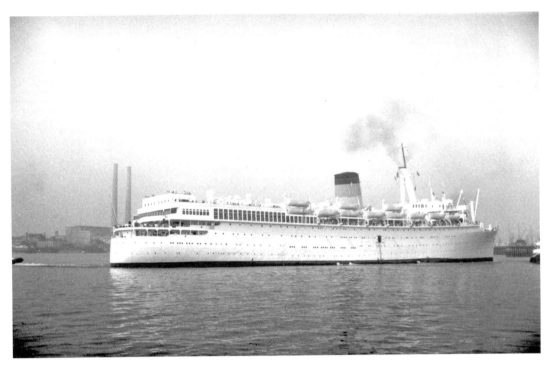

Arkadia in mid river, ready to depart for Le Havre, Cobh and Montreal on 26 July 1964.

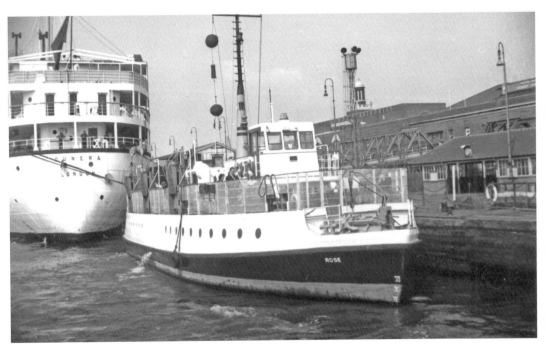

The ferry *Rose* and the British India Steam Navigation Co.'s *Dunera* at the Stage on 11 August 1964.

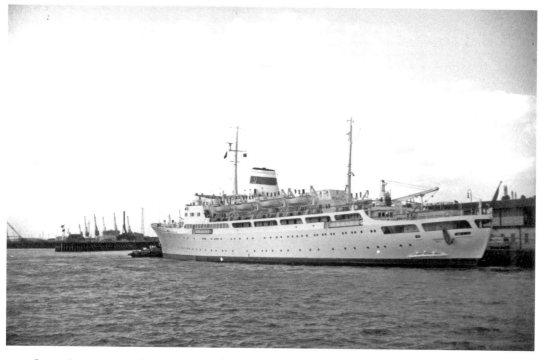

On 29 August 1964, the new Russian liner MV *Bashkiriya* (4,722grt) called at Tilbury.

Tessa, with a Ford Anglia aboard, is ready to land at the Stage on 8 December 1964.

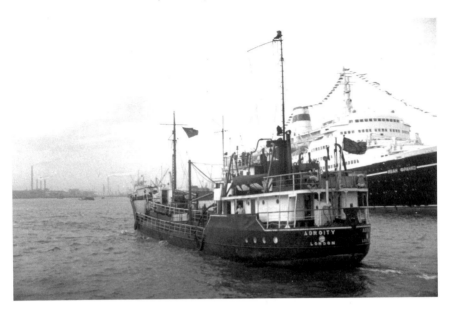

The *Adroity* (415grt, built 1947), a coastal tanker of the Everard fleet, passes the Russian *Ivan Franko* on 8 December 1964. Everard's still exist and are famous for their 1940s and 1950s advert by Frank Mason showing their fleet of vessels at ports all over northern Europe. They started with Thames sailing barges and merged with another famous coaster company, James Fisher's.

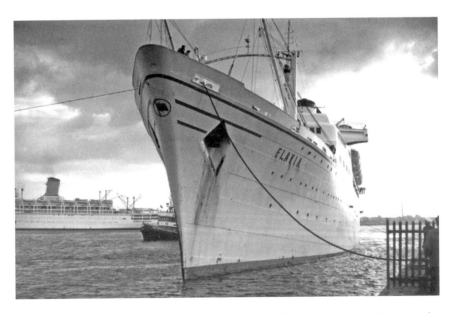

The Italan liner *Flavia* berthing on 26 June 1965. *Flavia*, a steam turbine, was the 1947 Cunarder *Media*, which had been built at John Brown's on the Clyde and which was sold out of Cunard service in 1961, to become Cogedar Line's *Flavia*. She was chartered in 1968 to Costa, and in 1982 sold to C.Y. Tung Group. In 1989, she was destroyed in a fire while refitting in Hong Kong and was scrapped in Hong Kong.

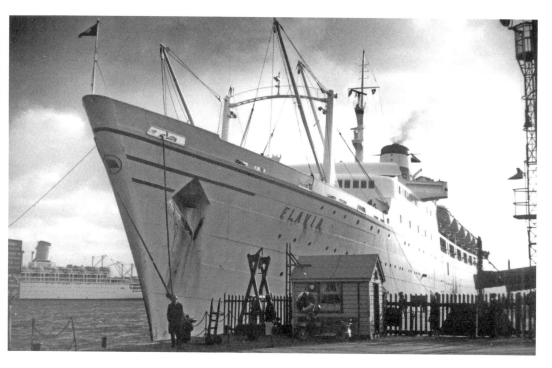

Behind the P&O liner *Himalaya*, *Flavia* is tied up at the Stage.

It is now *Himalaya*'s turn to berth. Built in 1949, she was the third vessel to have the name, and was scrapped in 1974, uneconomical to run in the seascape so altered by the Oil Crisis of the previous year. Passing is the Wilson Line's *Cattaro* (2,901grt, built 1945), which was sold in 1967 to Panamanian shipowners.

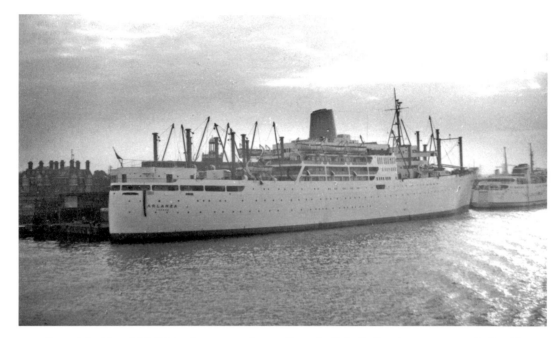

One of the Royal Mail Lines' passenger/cargo liners built in Belfast in 1959-61 and all sold for conversion to car carriers, the MV *Arlanza* (20,362grt, built 1960) at the Stage with 'The Londoner' ferry ahead of her.

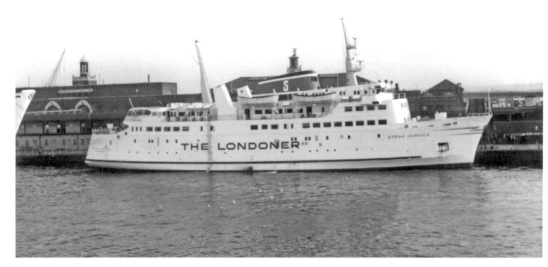

Stena Nordica, the Swedish ferry, at Tilbury, 9 July 1965. She was almost brand new at this stage and was used as part of 'The Londoner' series of ships on the route from Tilbury to Calais, which operated in July 1965. By October she was operating in Sweden and she appeared in Sealink livery on the Stranraer-Larne service from January 1966 to 1970. She was wrecked in May 1980.

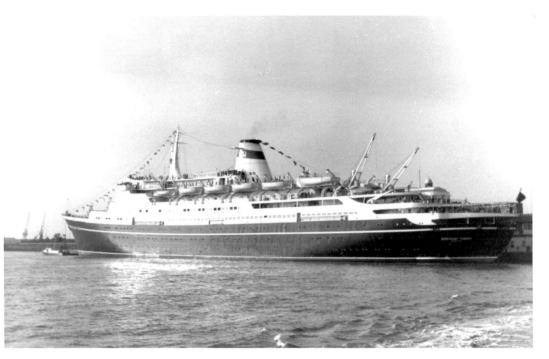

One of the most famous of the Black Sea Shipping Co.'s fleet was the *Aleksandr Pushkin*, shown here on 24 October 1965. For many Brits, this ship brought their first taste of cruising and she was the first Russian ship to have a discotheque installed in the 1970s. By 1985 she had been sold and is known today as the *Marco Polo*, still introducing people to cruising.

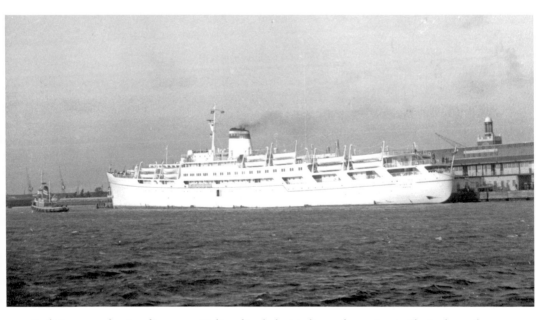

Built in 1939, the *Aurelia* was an Italian diesel-electric liner of 10,480grt. She is shown her on 6 December 1965.

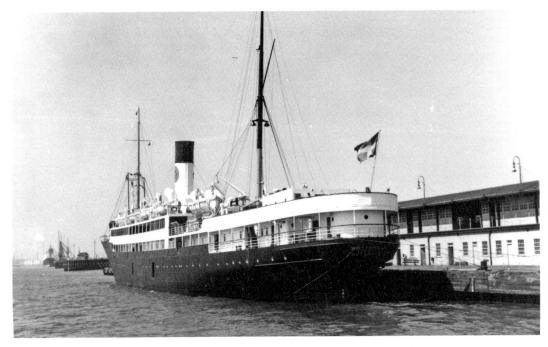

The Swedish Lloyd vessel *Britannia*, shown her on 20 April 1966, is on her last season with Swedish Lloyd, after a career of thirty-seven years.

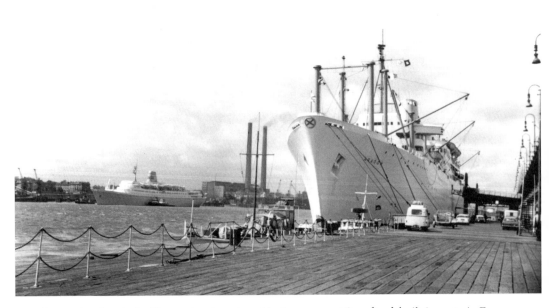

Across the river is the Norwegian American Line's 24,002grt *Sagafjord*, built in 1965 in France, while at the Stage is the Royal Mail Lines MV *Aragon*. *Sagafjord* ended her career with Saga as the much loved *Saga Rose*, but was scrapped as new SOLAS regulations made her outdated.

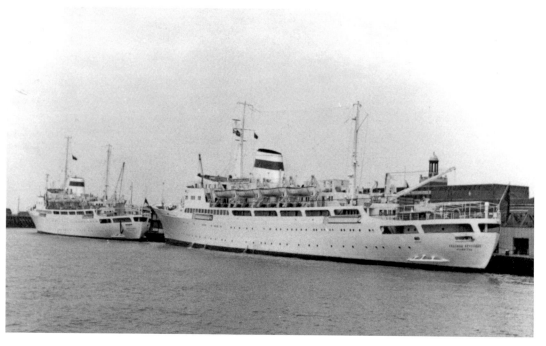

Two Russian vessels, the *Maria Ulyanova* (built 1960, 4,720grt) and the *Nadesha Krupskaja* (built 1963, 5,261 grt) on 11 June 1966.

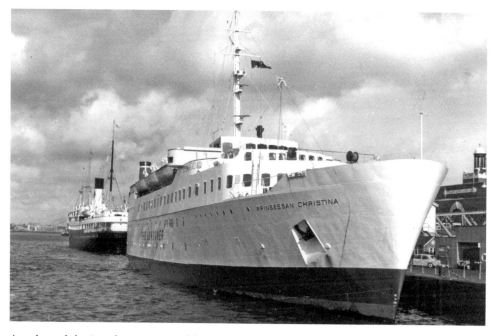

Another of the Londoner series of ferries was the MV *Prinsessan Christina* (2,239grt, built 1960). She was chartered for 1966 by Stena and was named after the Swedish princess. She is at the Stage on 18 June 1966, with *Suecia* or *Britannia* behind.

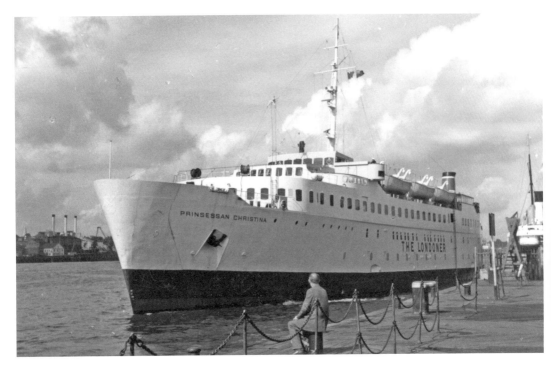

Prinsessan Christina departs for Calais on 18 June 1966.

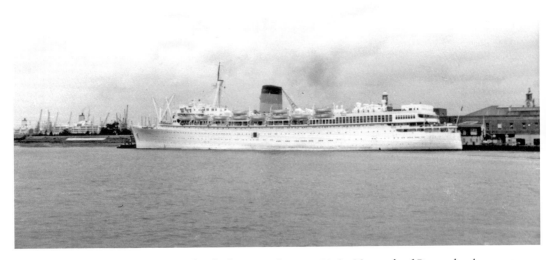

The Greek turbo-electric vessel *Arkadia* on 22 June 1966. As *Monarch of Bermuda*, she spent her war years carrying troops, caught fire while being refitted and was rebuilt as the emigrant ship *New Australia*.

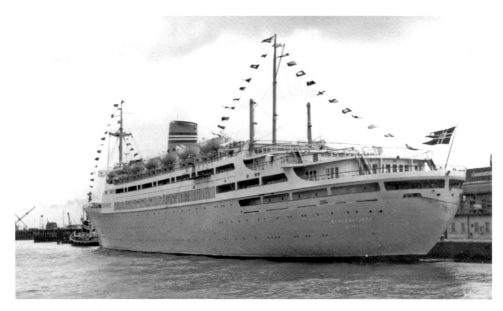

One of the most renowned of the transatlantic steamship companies was the Norwegian America Line. Famed for their quality of service, their ships called occasionally at London on their way to American ports and on cruises. On 25 August 1966, the ten-year-old, 18,739grt MV *Bergensfjord* is dressed overall at the Stage. Sold in 1971, the *Bergensfjord* became the French Line's *De Grasse*.

Another company which used Tilbury was Fred. Olsen. Some of their ships were convertible from ferry to cruise ship to suit the demands of trade and the seasons. The 1966 MV *Black Prince* was jointly owned by Olsen and the Bergen Line and alternated name between *Black Prince* and *Bergen*. On 2 November 1966, she is shown in her Olsen livery at the Stage.

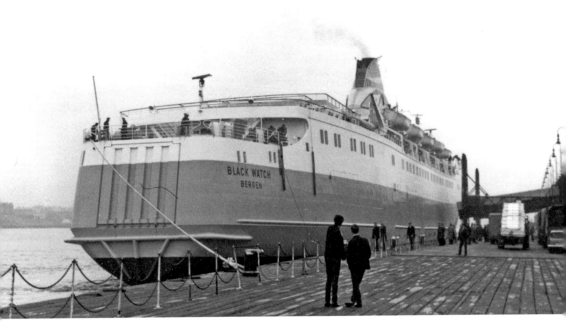

Another jointly owned vessel was *Black Watch/Jupiter*, again built in 1966, and with her stern-loading door shown to full advantage, on 9 November 1966.

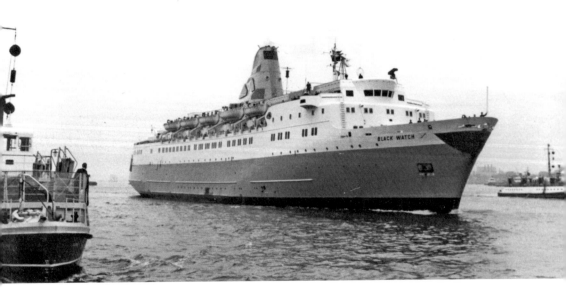

Black Watch departs the Stage. She was sold in 1986 to the Norway Line as *Jupiter*.

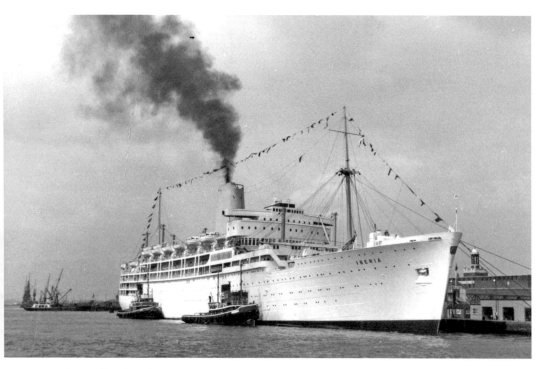

Dressed overall and with two tugs at her side, the P&O *Iberia*'s funnel is belching smoke as she begins to depart the Stage on 22 April 1967. Built in 1954, she was scrapped in 1973.

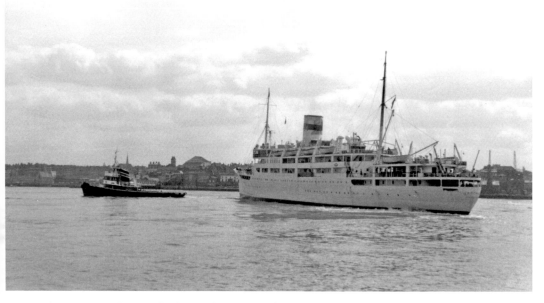

Built in 1940 as the *Vyacheslav Molotov*, one of the Joseph Stalin class of passenger ships, the *Baltika* (7,494grt) spent part of her war years as a transport vessel. She was renamed to *Baltika* in 1957.

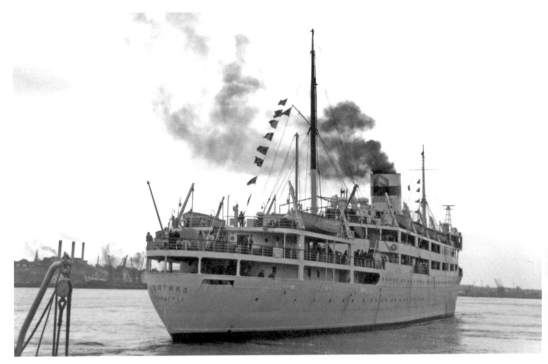

In 1971, *Baltika* repatriated many Russians expelled from Britain as spies and was scrapped in 1987. Leaving Tilbury on 22 April 1967, she was a frequent sight in the Thames.

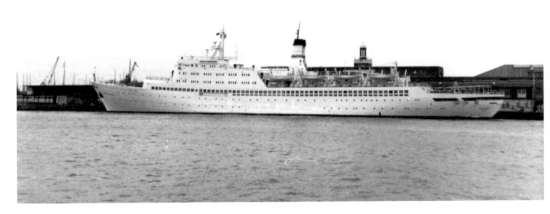

The East Germans also used their merchant marine as a useful way of collecting Western currency and the gas-turbine *Fritz Heckert* (8,120grt, built 1961) is shown here on a visit to Tilbury on 29 April 1967. She was funded by one of the East German trade unions as a holiday ship for members. She was scrapped in India in 1999.

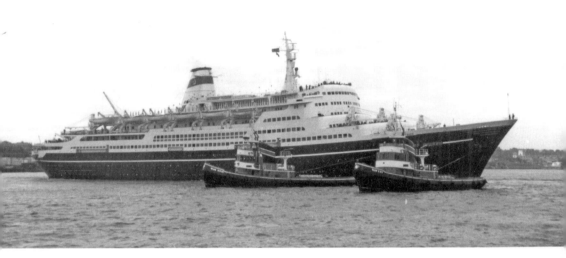

The *Aleksandr Pushkin* off Tilbury, 21 June 1967, with two Sun tugs (*Sun XXIV* and *Sun XXV*) in attendance.

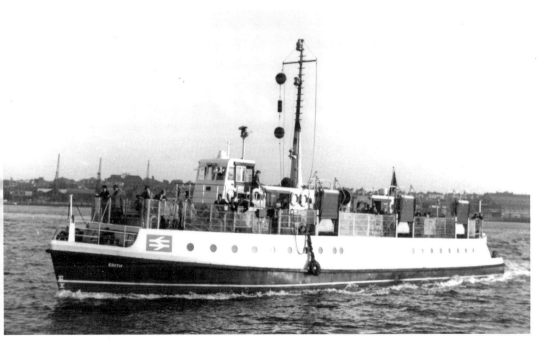

The passenger ferry MV *Edith* in the river on 1 July 1967.

The 1960 Russian MV *Maria Uljanowa* on 8 July 1967.

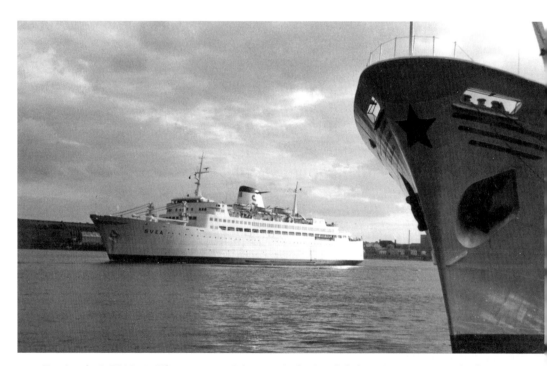

Passing the MV *Maria Uljanowa* on 8 July 1967 is the Swedish ferry *Svea* (7,883grt, built 1966). *Svea* was owned by the Stockholms Rederi AB Svea. She was initially operated on the 'England-Sweden Line' car-ferry service from Hull to Gothenburg but is shown here on the Thames a year after she was built. She would return to the Thames in the 1970s as the *Saga*.

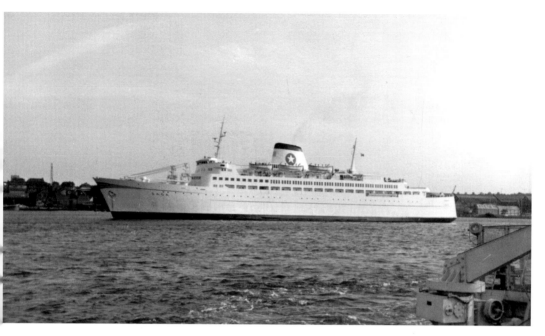

Svea's sister, also called *Saga*, was built in 1966 for Swedish Lloyd as part of a three-ship contract with the shipbuilders. She operated from Tilbury to Gothenburg until she was sold to Stena in 1971, changing her name to *Stena Atlantica*. She still sails today (2013) as *Sancak 1*.

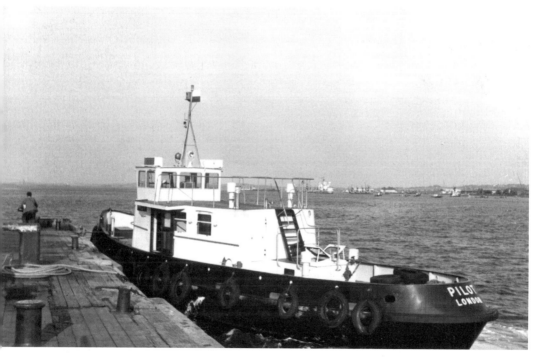

The tug MV *Pilot* at Tilbury Stage on 15 July 1967.

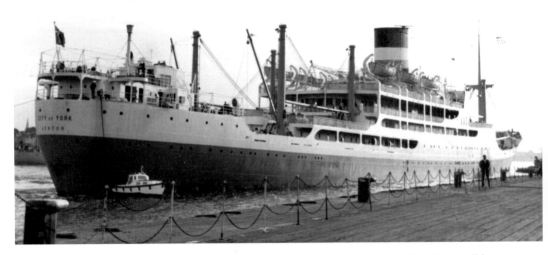

The Ellerman Line's *City of York* berthing at the Stage on 15 July 1967. Note the small boat at her stern ready to bring the lines to the Stage so she can be tied up and warped in. Built in 1953, the MV *City of York* was sold in 1971 to Greek owners.

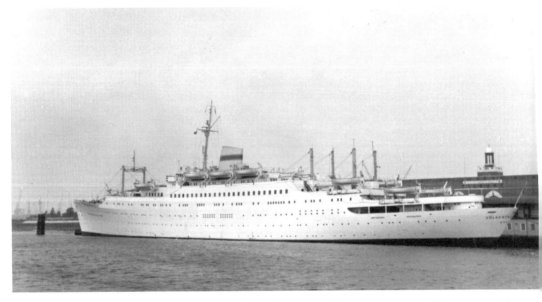

East Germany's MV *Volkerfreundschaft*, shown here on 28 August 1967, started her career with the Swedish America Line as their *Stockholm*. Built in 1949, she is most famous for having rammed and sunk the Italian liner *Andrea Doria* in mid-Atlantic. Sold in 1960 to the East Germans, she has had a chequered career, including being attacked by pirates and now sails for a Portuguese cruise line.

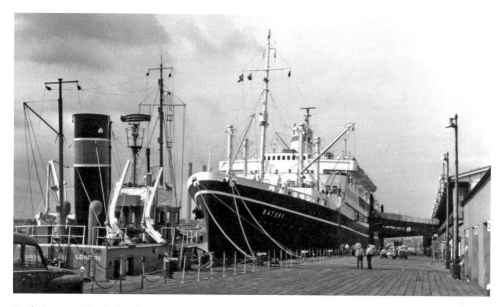

Built in 1936 in Italy, the 14,287grt MS *Batory* was part-paid for in shipments of Polish coal. Used on the Gydnia-New York run pre-war, she was requisitioned during the war and transported much of Britain's gold reserves to Canada in 1940, as well as in the evacuation of Dunkirk. Returned to Poland after the war, she is shown here on 20 August 1967, four years before she was scrapped in Hong Kong.

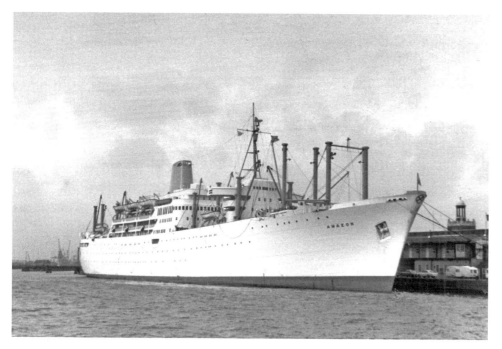

The Royal Mail Lines' MV *Amazon* at the Stage on 27 January 1968. Caravans destined for export are lined up at her bow.

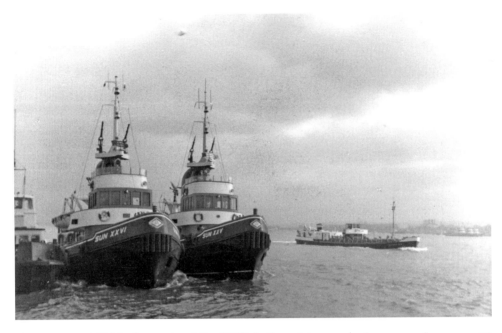

The tugs *Sun XXVI* (built 1965) and *Sun XXV* (built 1963) are at the Stage on 27 January 1968 as the BP tanker *B.P. Haulier* passes up river.

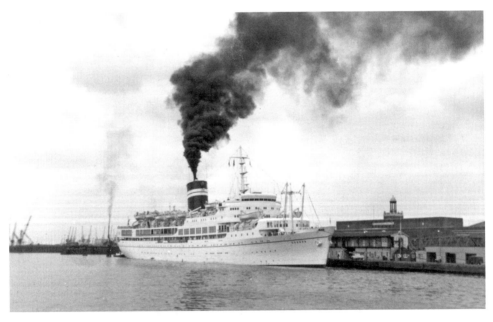

On a schools educational cruise, the SS *Uganda* of the British India Steam Navigation Co. prepares to depart Tilbury on 4 May 1968. She would survive the Falklands War but was blown ashore at Kaohsiung, Taiwan, during Typhoon Wayne and capsized, while waiting to be scrapped in 1986. She was not broken up until 1992. Her maiden voyage as a school ship was in February 1968.

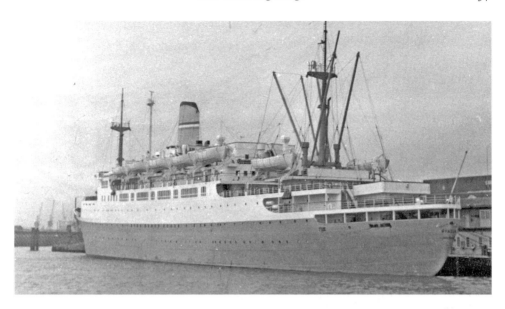

Holland America Line's SS *Rijndam* was an unusual visitor to the port. Built as the *Dinteldijk*, she was converted while building into a passenger vessel as the *Rijndam*. She was chartered out in 1966 and 1967 as the *Waterman* but reverted to HAL service in 1967 and is shown here on 13 May 1968. She sank on the way to the breakers in 2003.

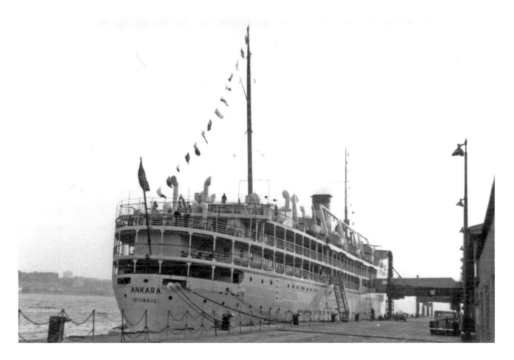

The Turkish steamer SS *Ankara* (6,178grt, built 1927) on 9 July 1968. Starting life as the SS *Iroquois*, she was used as the hospital ship *Solace* and sold in 1948 to the Turkish Maritime Lines. She was broken up in Aliaga, Turkey, in 1981.

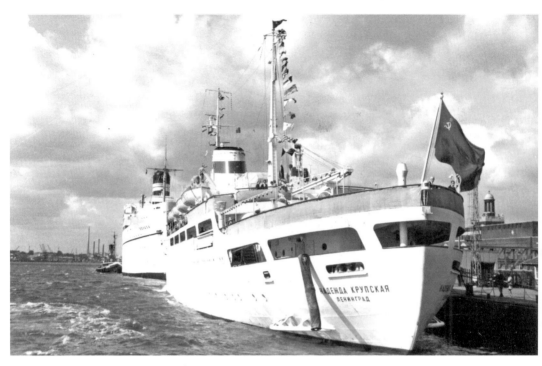

British India's *Nevasa* dwarfs the Russian *Nadeshda Krupskaja* on 21 September 1968.

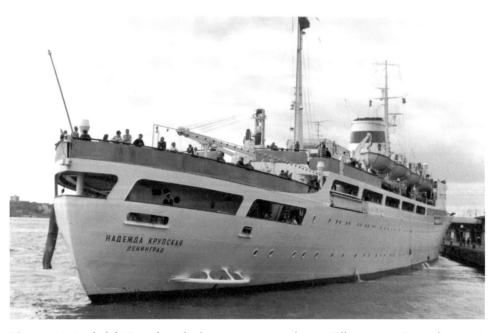

The Russian *Nadeshda Krupskaja* (built 1963, 5,261grt) departs Tilbury on 21 September 1968. Note the chute at her port-side over the stern for disposing of waste. This kind of dumping is now banned under international treaty.

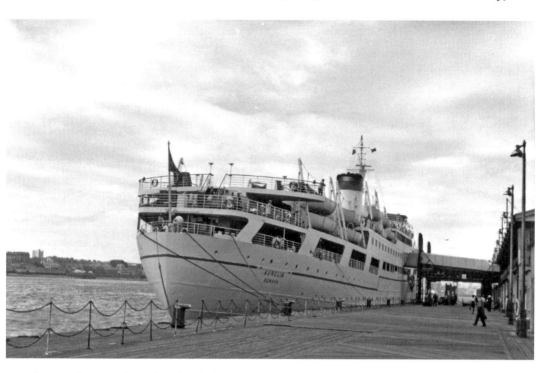

On 19 July 1969, the Italian diesel-electric liner *Aurelia* visited Tilbury.

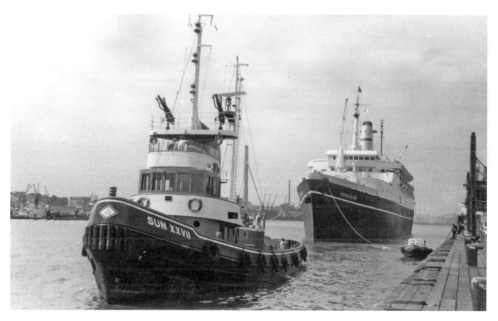

The Polish Ocean Line replaced the *Batory* with the TSS *Stefan Batory* in 1968. Shown here on 1 September 1969, she was the last true ocean liner, finally being withdrawn from her service to Montreal in 1988. Staring life with Holland America as the *Maasdam*, she was scrapped in Aliaga, Turkey, in 2000.

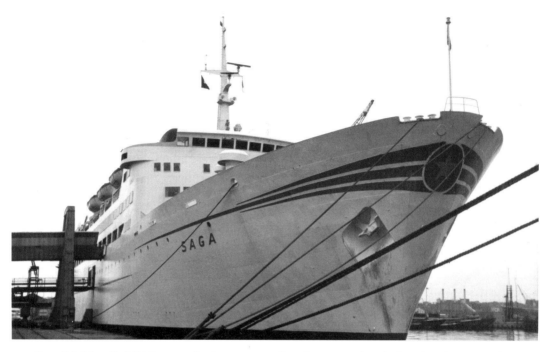

Swedish Lloyd's MV *Saga* at the Stage on 26 October 1969, just before her departure for Gothenburg.

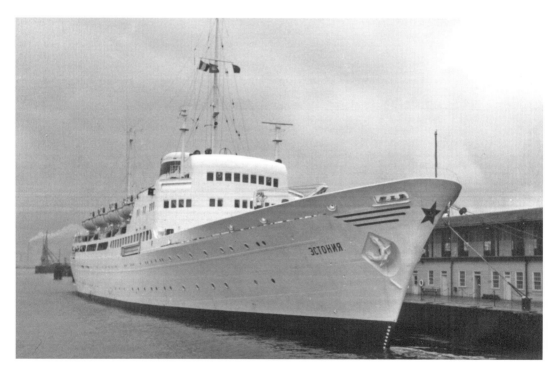

Russia's MV *Estonia* of 1960 at Tilbury on 20 August 1970.

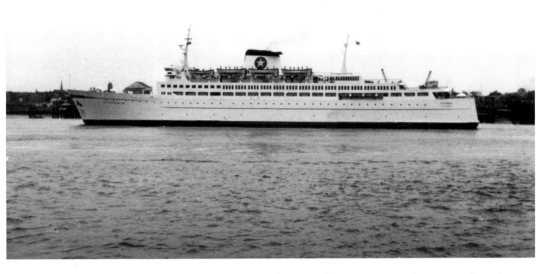

In 1968 Swedish Lloyd purchased the *Svea* and renamed her *Hispania*. She was used on the Southampton-Bilbao route but was transferred in 1970 and then renamed in 1972 as *Saga*.

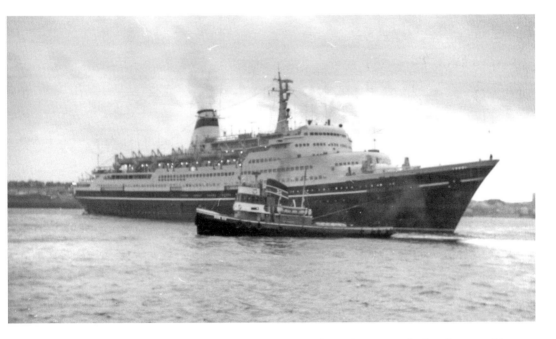

Lasting fifteen years for Lauro, the *Angelina Lauro* sank on the way to the breaker's yard in 1979. Her first eight years with the company were spent on the Australian route, the last to be affected by jet travel, before she spent her twilight years as a cruise ship.

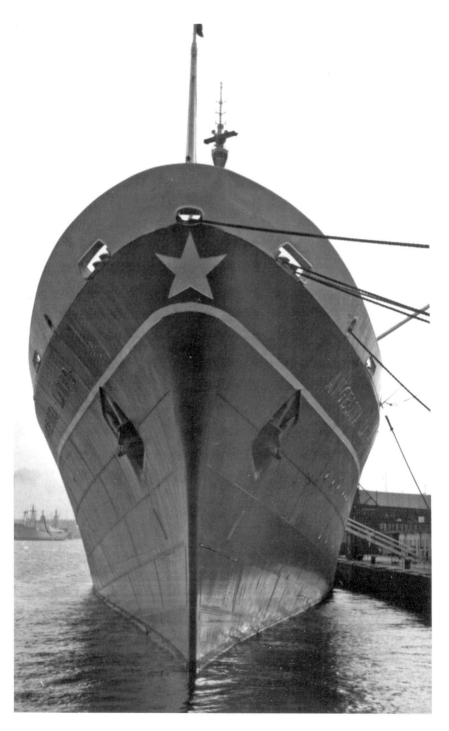

Bow on and from the ferry is the *Angelina Lauro* of Lauro Lines on 9 July 1971. This
Italian vessel, of 24,377grt, was built in 1939 as the *Oranje* and lasted for twenty-
five years under this name, before becoming the *Angelina Lauro*.

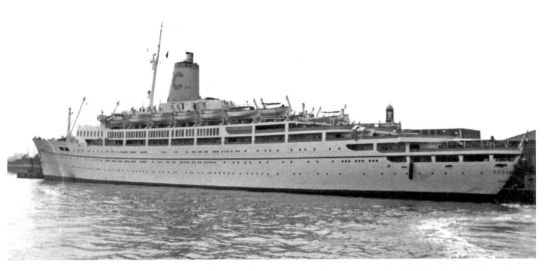

Costa was another operator of 'Ten Pound Pom' assisted passages and the *Federico C* of 1958 is shown here on 19 August 1971. She was the first new build for Costa and ended her career in 2000 with Premier Cruises. She too sank on her final voyage.

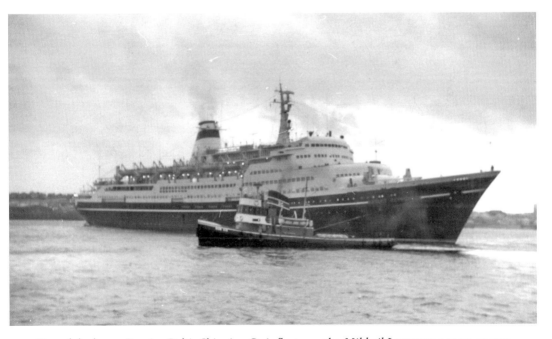

One of the larger Russian Baltic Shipping Co.'s fleet was the *Mikhail Lermontov* at 19,500grt. Built in 1972, she was one of the last of the 'poet' class of vessels. In 1986, she ran aground off the coast of New Zealand with one casualty.

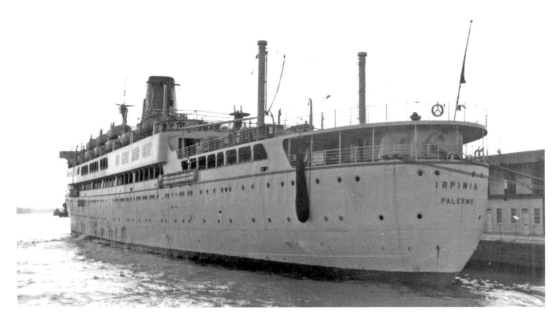

Laid down as the *Campana* at Swan Hunter's on Tyneside in 1929, the *Irpinia* was bought by the Grimaldi-Siosa Line in 1955 and used for cruising. Here at Tilbury on 2 June 1972, she was used in the filming of the *Voyage of the Damned*, about Jewish refugees escaping from Germany to Cuba. Laid up in 1981, after fifty-two years of service, she was scrapped at La Spezia two years later.

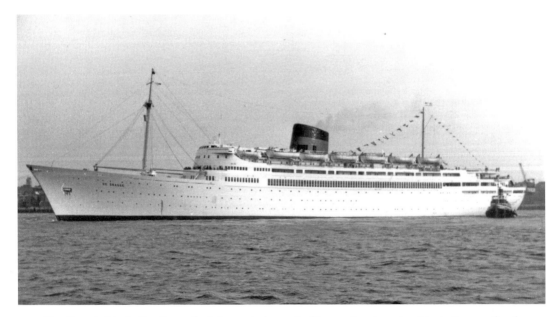

The French Line's *De Grasse* had formerly been the Norwegian America Line's *Bergensfjord*. Off Tilbury on 14 July 1972, this was soon after the refit that saw her re-emerge as *De Grasse*.

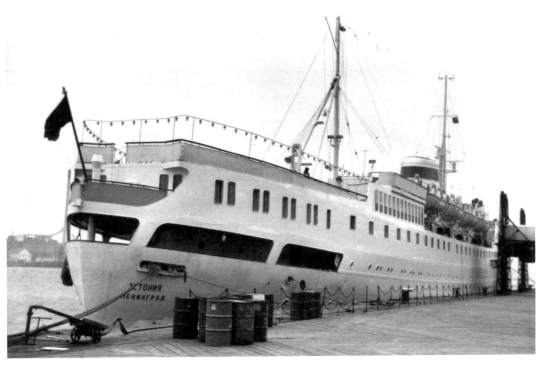

MV *Estonia* (4,871grt, built 1960) at Tilbury on 16 September 1972.

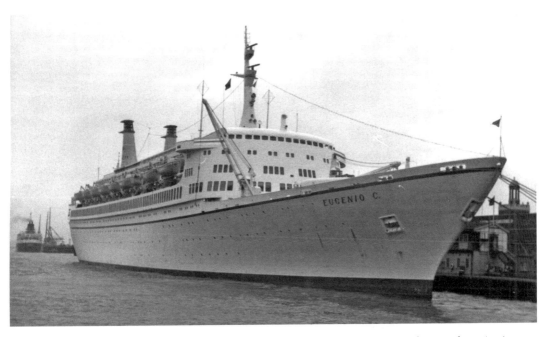

Costa Line's *Eugenio C* was ordered for their South American service and entered service in 1966. She left Costa in 1996 and went through a series of owners until she was scrapped as *Big Red Boat II* in 2005 at Alang, India. This fine ship is shown here on 23 August 1973.

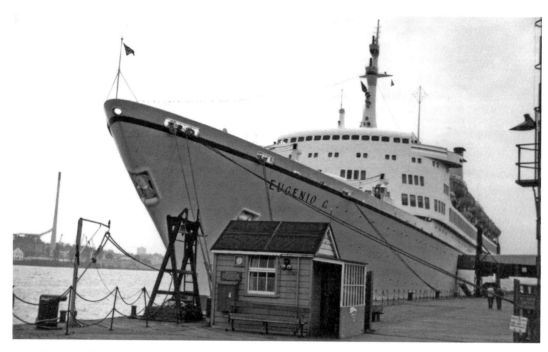

Eugenio C's bow.

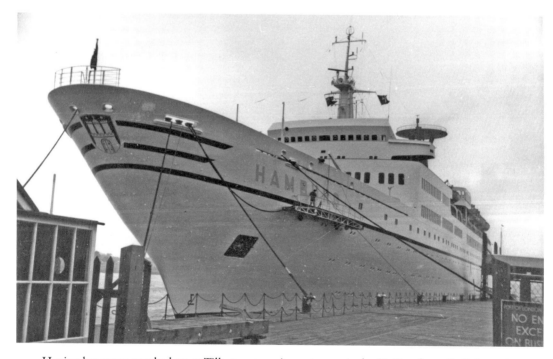

Having her name touched up at Tilbury on 29 August 1973 is the SS *Hamburg*. Built in 1969, she was built for the German Atlantic Line and renamed TSS *Hanseatic*. In 1974 she was sold to the Black Sea Shipping Company and became the *Maksim Gorkiy*.

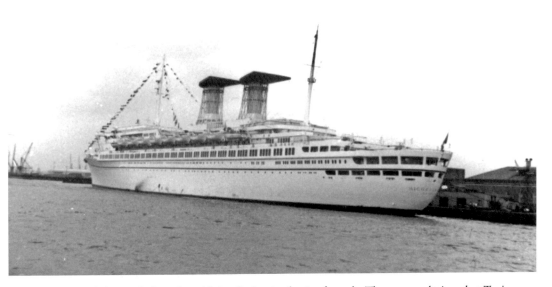

Italia owned the *Michelangelo*, with its distinctive lattice funnels. These were designed at Turin Polytechnic to assist in the removal of smoke from the after decks. The *Michelangelo* was one of the last true ocean liners ever built. In 1975, she was sold to Iran and used as a floating barracks. Scrapped in 1991, she is shown here on 1 August 1974.

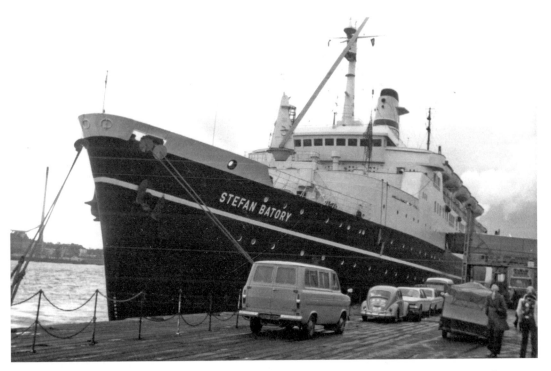

The *Stefan Batory* on 3 November 1974. Vehicles on the quayside include a Ford Transit minibus, Volkswagen Beetle, BMW 3.0, Mercedes W123 and a Volkswagen bay window camper.

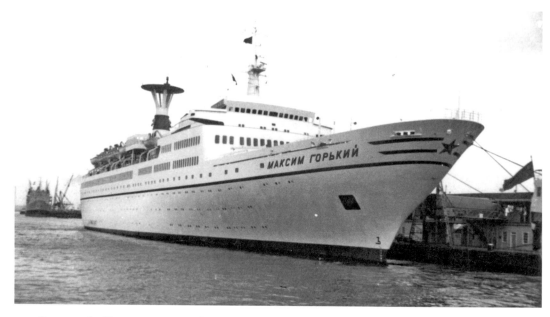

In 1974, the *Hanseatic* (ex-*Hamburg*) was sold to Russia to become the *Maksim Gorkiy*. Before she set sail for the Black Sea Shipping Co., she was used in the film *Juggernaut*. By 23 April 1975, she was in exotic Tilbury. Her funnel design was as distinctive as the *Michelangelo*'s. She reached a beach in India on 26 February 2009 and was broken up there.

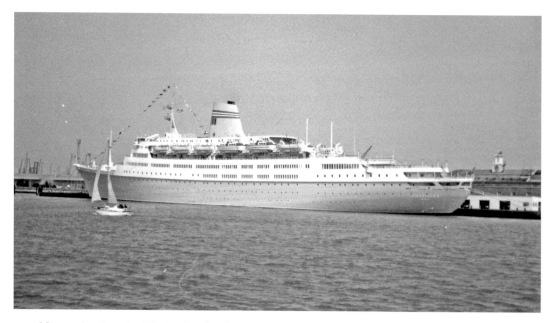

Norwegian America Line's *Vistafjord* was the last major ocean liner built in the UK, in 1973. Larger than her sister *Sagafjord*, she will end her career with Saga Cruises, making her last voyage for the line in January 2014. On 22 June 1975, she visited Tilbury. With *Vistafjord* dressed in flags, a yacht looks diminutive in comparison.

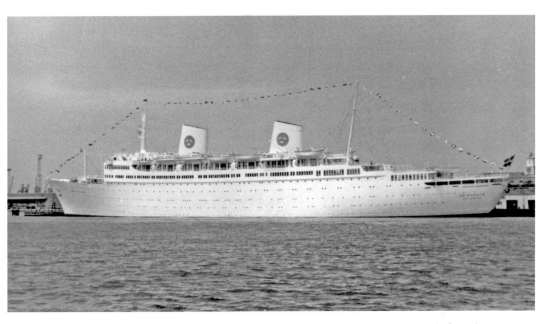

Swedish American Line's *Gripsholm* was built in 1957 and had not long to go before she was laid up in August 1975, barely two months after she is depicted here on 24 June that year. Still immaculate she was sold to Karageorgis Lines. After a career as a cruise ship, she sank on tow to the breakers in 2001.

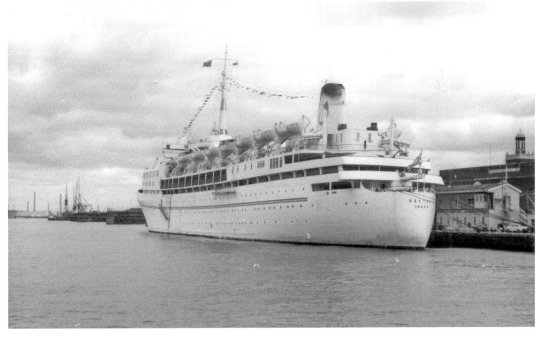

Another ship to survive for a while in Greek ownership was the SS *Calypso*, formerly the Shaw Savill liner *Southern Cross*. She called at Tilbury four days after *Gripsholm*, on 28 June 1975.

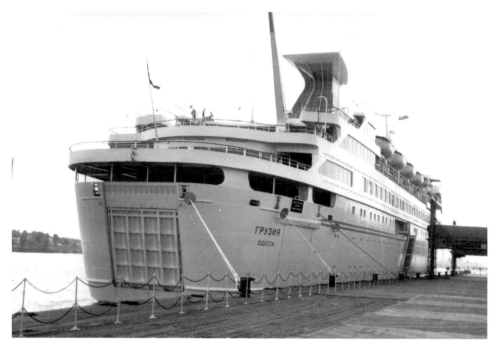

The Russian MV *Gruziya* (16,631grt, built 1975) on 9 July 1975. Note the side and stern loading doors.

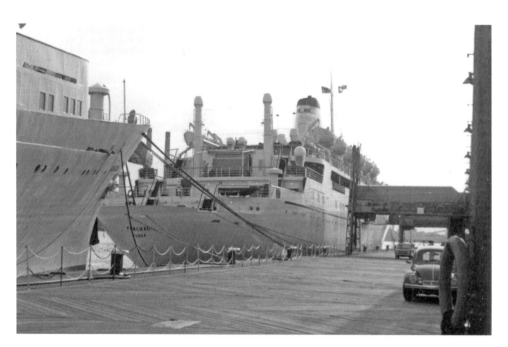

On 17 May 1976, the Portuguese liner *Funchal* (9,845grt, built 1961) called at Tilbury. Originally built for the Lisbon-Madeira-Azores service the *Funchal* was refitted to become a very successful small cruise ship. Just refitted, it is hoped she will last another two decades in service.

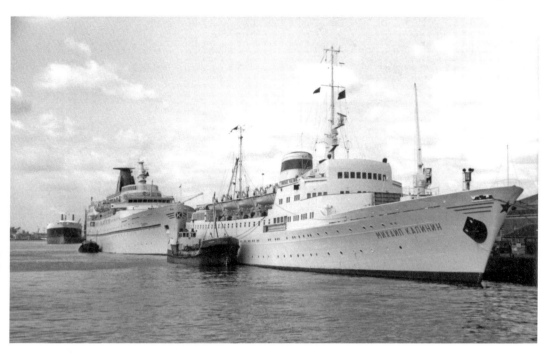

Two ships were berthed at the Stage on 5 September 1976. The ship astern of the *Mikhail Kalinin* is the Greek MV *Daphne*, which was built in 1955 as Furness Bermuda's *Ocean Monarch*.

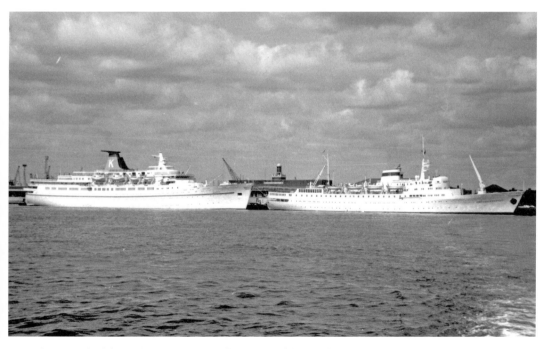

Photographed from the river, the *Daphne* and *Mikhail Kalinin* looks resplendent in their white liveries.

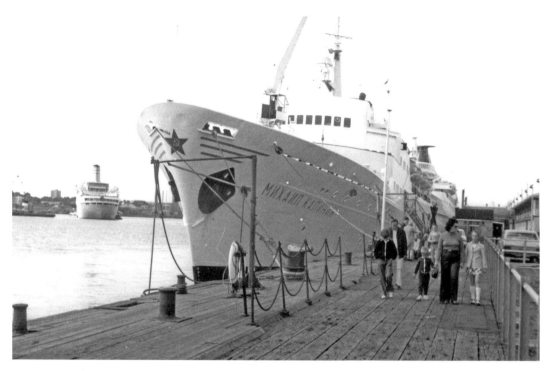

One of the Norwegian America Line ships (*Vistafjord* or *Sagafjord*) is across the river from *Mikhail Kalinin* on 5 September 1976.

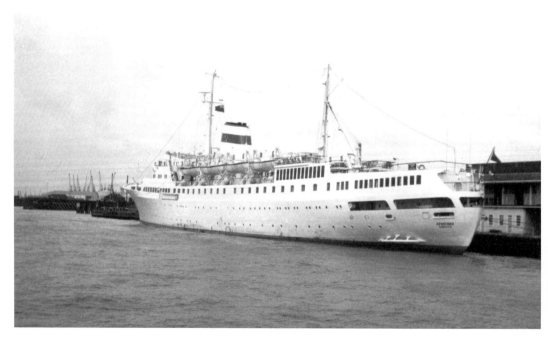

On 4 May 1977, the Russian MV *Armeniya* (5,169grt, built 1963) is berthed at the Stage.

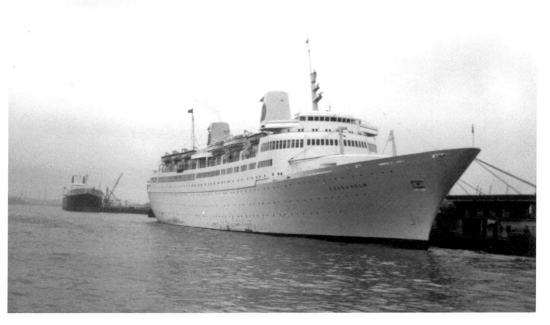

Having been sold by the Swedish American Line in 1975 to Flagship Cruises, the Clyde built MV *Kungsholm* is shown here on 14 June 1977. In 1978 she was purchased by P&O and renamed *Sea Princess*, then *Victoria* and when sold from service in 2002, she became *Mona Lisa*. She is now berthed as a floating hotel in Oman.

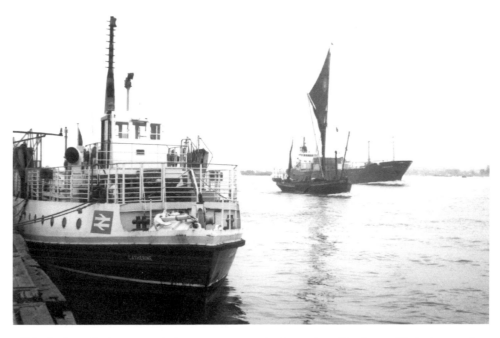

While the ferry *Catherine* awaits her passengers at the Stage, the sailing barge *Gladys* is overtaken by the MV *Towerstream* on 12 July 1977.

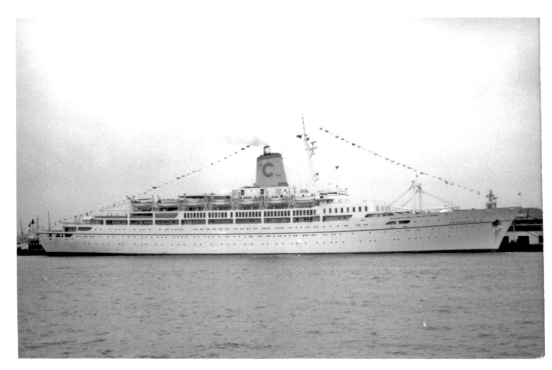

Costa Line's *Federico* C at the Stage, 28 July 1977.

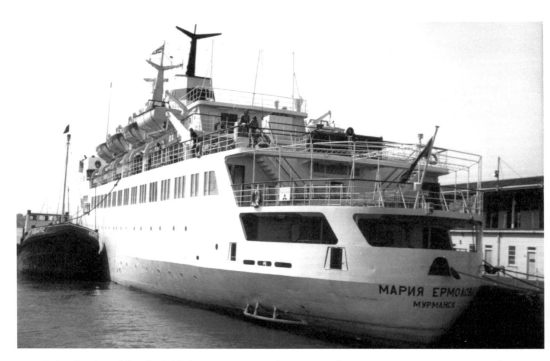

Being bunkered by the MV *Aquatic* on 30 July 1977 is the Russian MV *Mariya Yermolova* (3,941grt, built 1974).

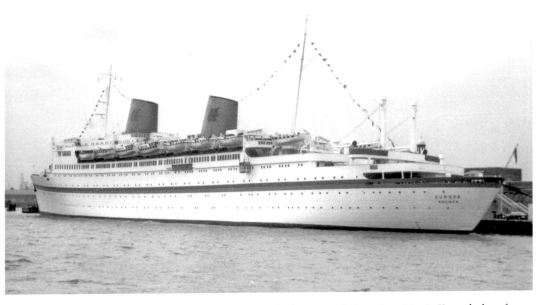

The Hamburg America liner *Europa* was formerly the Swedish American Line's *Kungsholm* of 1953. In 1984, as the *Columbus C* she hit a breakwater in Cadiz and sank. When refloated, she was sent for scrap in 1985 in Barcelona.

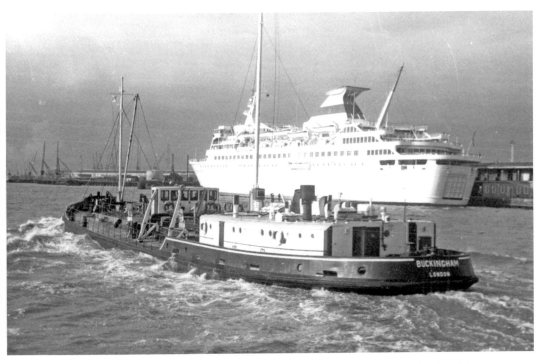

Passing the Russian MV *Kareliya* on 2 November 1978 is the 1967 motor tanker *Buckingham*.

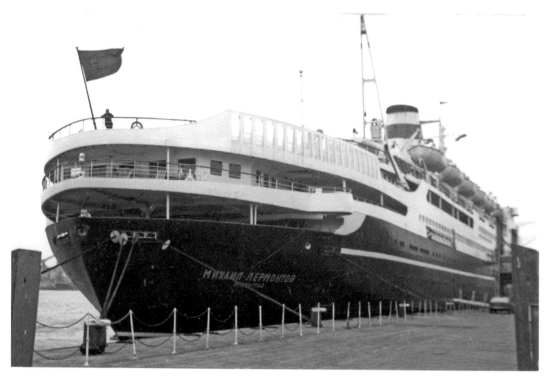

Another of the Black Seas fleet was the MV *Mikhail Lermontov*, shown here on 5 March 1980.

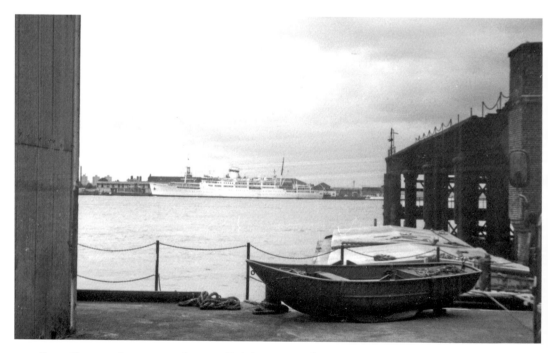

From Gravesend we can see the 1940 *Baltika* on 12 July 1980.

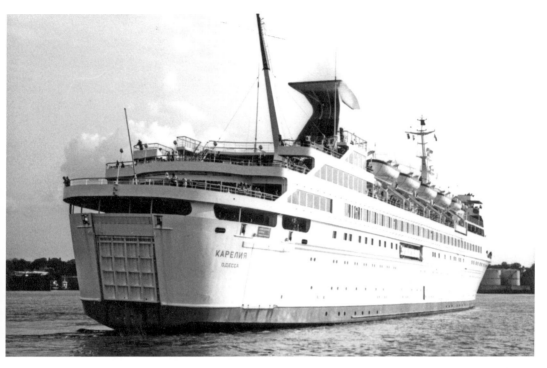

The MV *Kareliya* off Tilbury on 8 May 1981. By this time, the upper docks were in terminal decline as containerisation had taken over and fewer ships travelled upriver past TIlbury.

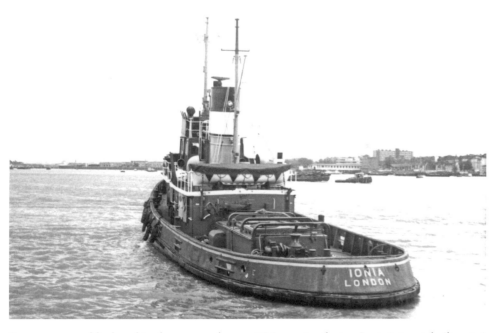

Some 21 years old when this photo was taken on 8 May 1981, the tug *Ionia* (187grt, built 1960) awaits a ship off Tilbury.

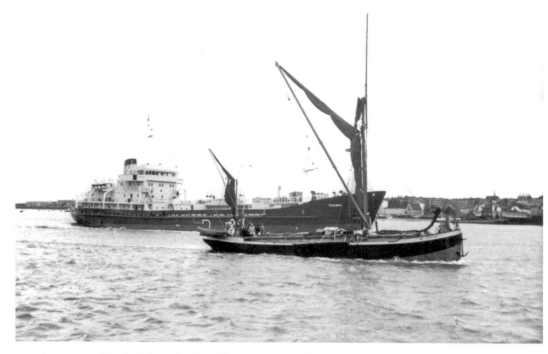

Being passed by the Motor Tanker *Thames* (2,663grt, built 1977) is the sailing barge *Decima* on 25 May 1981. Once a common sight on the Thames, some of the barges were still working in the 1980s although most had passed into preservation by then.

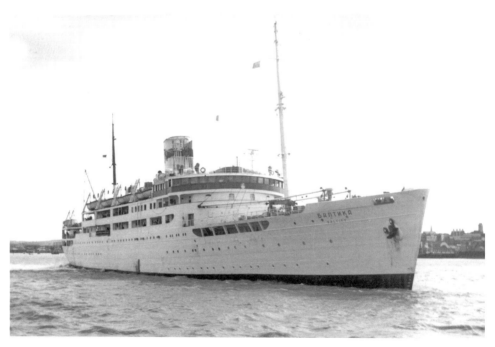

Baltika in mid-river, departing Tilbury on 2 October 1981.

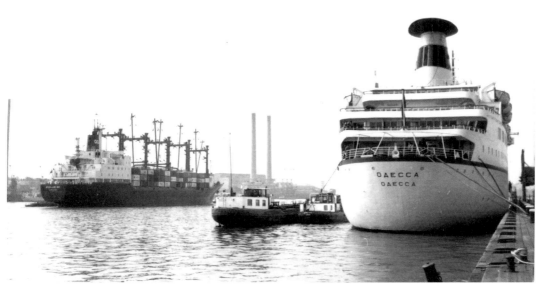

Heading for the Port of Tilbury on 14 April 1982 is the container ship MV *Studland Bay* (built 1980). At the Stage is the Russian MV *Odessa* (13,758grt, built 1974).

The British tug *Sun XXVI* off Tilbury on 16 April 1982.

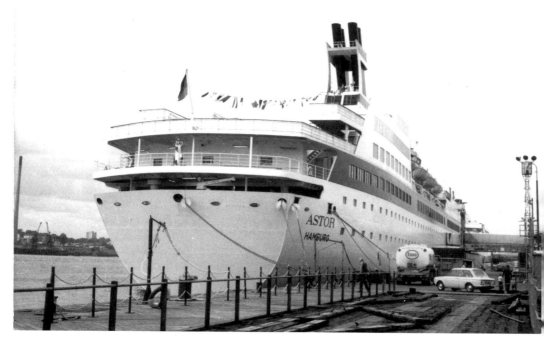

With a Hillman Imp and an Esso tanker on the Stage itself, the German MV *Astor* is dressed overall on 24 May 1982.

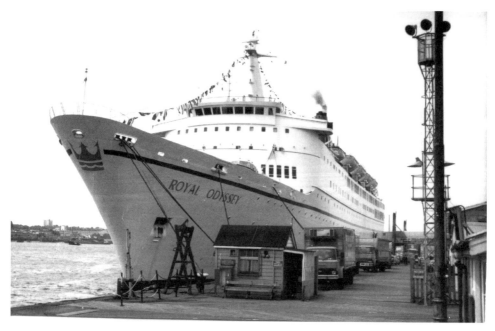

By the early 1980s cruise ships were beginning to call. No longer were ocean liners visiting, but a steady stream of cruise ships such as the *Royal Odyssey* were travelling to the Stage, as shown here on 11 June 1982.

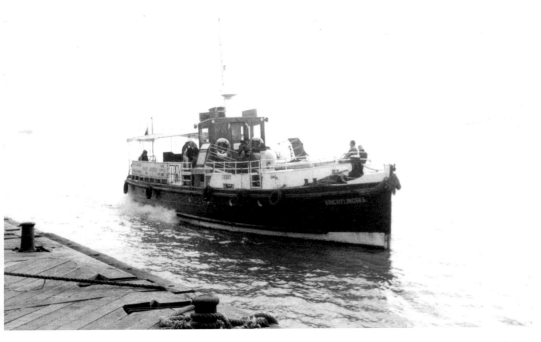

The *Brightlingsea* was built in 1925 for the ferry service between Harwich and Felixstowe and was a rare visitor to the Thames. Here she is on 9 October 1982 at the Stage.

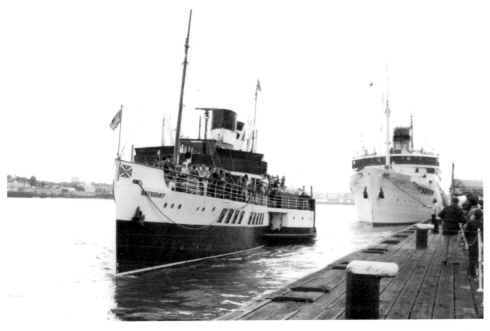

With *Baltika* behind her, the PS *Waverley* approaches the Stage on 15 September 1984. Built in 1947 for the LNER, she is the last remaining sea-going paddle steamer in the world and makes regular voyages from the Thames each year.

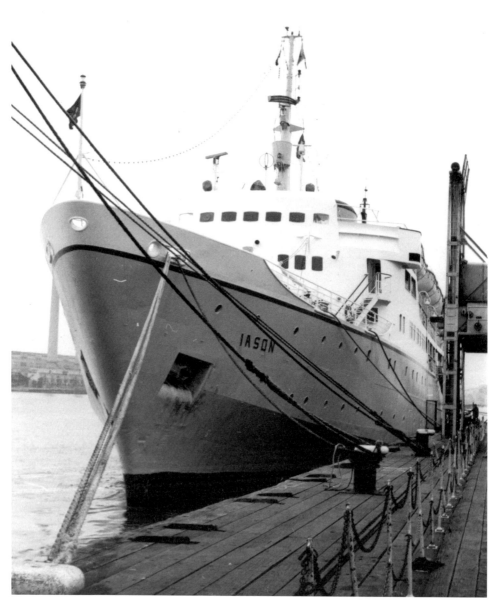

The Greek MV *Jason* at the Stage on 14 May 1984. She had been built in 1965 by Cantieri Runiti dell' Adriatico at Monfalcone as war reparation to the Greeks by the Italian government and was launched as the *Eros*. Converted to the *Jason*, a luxury cruise ship, she eventually became the MS *Ocean Odyssey* and was broken up at Alang in 2010.

Chapter Two

The Port of Tilbury

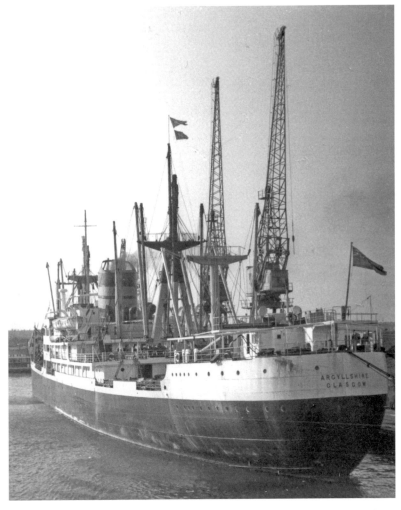

Powered by three Parsons steam turbines, the *Argyllshire* was built in Greenock in 1956 and was operated by both the Clan Line (as shown here on 27 June 1964) and the Scottish Shire Line.

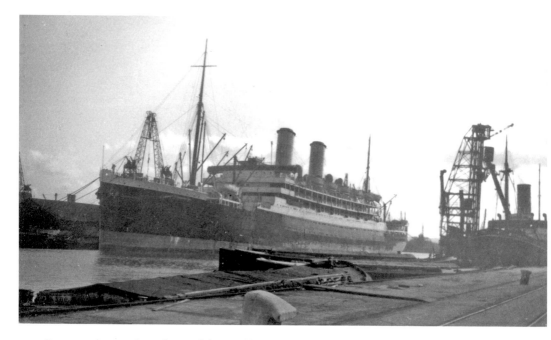

By 1949, the merchant fleets of the world were beginning to recover from the ravages of seven years of war. The Orient Line had called the Port of Tilbury home for many years, and Tilbury was the home port of the *Otranto* (20,051grt, built 1925). She is shown here on 15 October 1949.

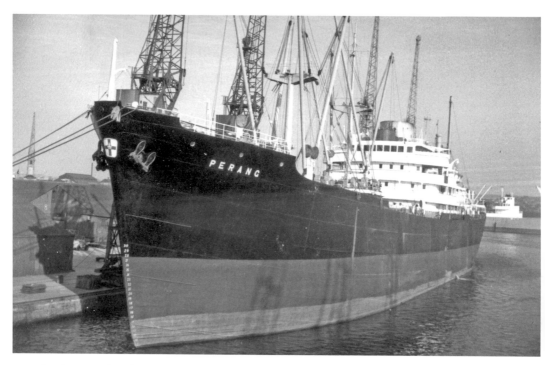

On the same day, the MV *Perang* (6,177grt, built 1954) was berthed on the port.

The brand new 2,760grt ferry MV *Gaelic Ferry* heads towards the *Perang* on 27 June 1964. She was built by Swan Hunter on the Tyne for the Atlantic Transport Navigation Co. For 1964, she sailed between Tilbury, Antwerp and Rotterdam before changing to the Felixstowe–Rotterdam route in 1965. In 1988, she reached Taiwan for breaking, despite breaking her tow on two occasions.

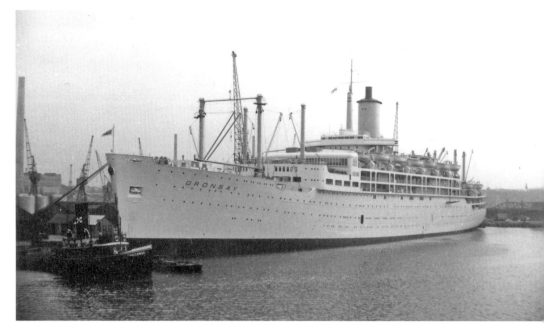

Orient Lines' SS *Oronsay* (27,632grt, built 1950) on 5 July 1965. *Oronsay* was the second post-war Orient Line vessel and was constructed at Vickers-Armstrong at Barrow. Used in the filming of *Carry On Cruising*, she was broken for scrap in 1975.

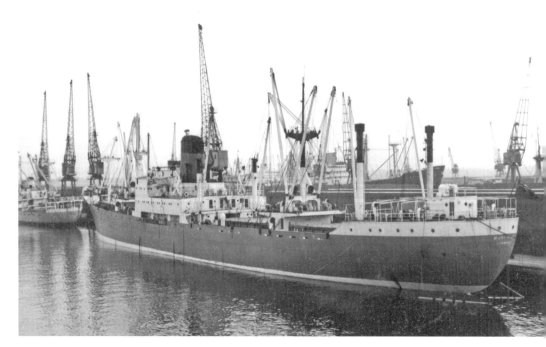

The Guinea Gulf Line's SS *Mary Holt* (5,577grt, built 1959) in Tilbury docks on 9 July 1965. Based in Liverpool, the Guinea Gulf Line traded to the west coast of Africa.

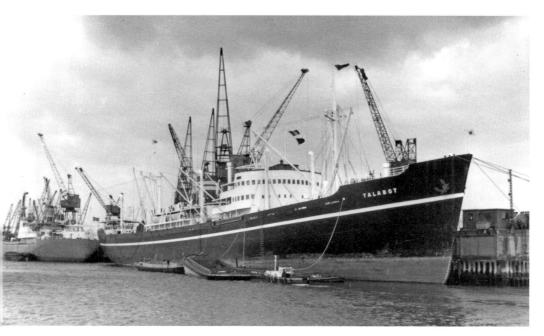

13 July 1966 and the Norwegian MV *Talabot* is berthed. Built in 1946 as part of the post-war expansion of the Norwegian mercantile marine, the *Talabot* was owned by Wilh. Wilhelmsen of Oslo and when sold was renamed *Belinda*.

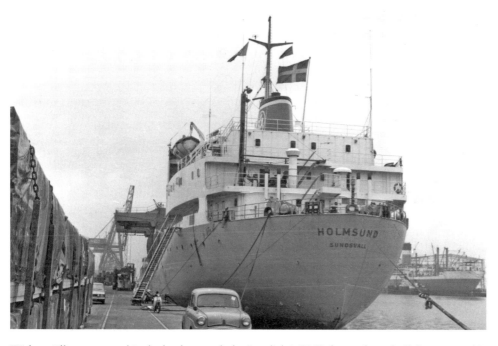

With an Ellerman vessel in the background, the Swedish MV *Holmsund* was built in 1967 and is shown here two years later on 29 March 1969.

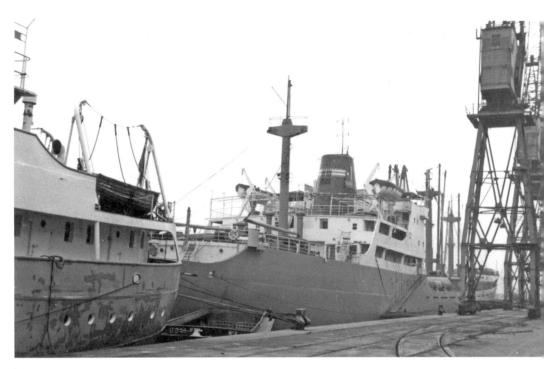

Cuba's MV *Jiguani* (9,390grt, built 1966), Tilbury docks 29 March 1969.

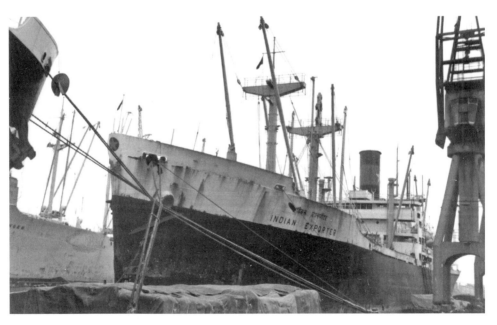

After the war, India built up a merchant marine, starting almost before independence. The *Indian Exporter* was built in 1945 as one of the American Vic ships and was launched as the *Temple Victory*. Being laid up in 1946, she was sold to the India S.S. Co. and was scrapped in Bombay in 1977.

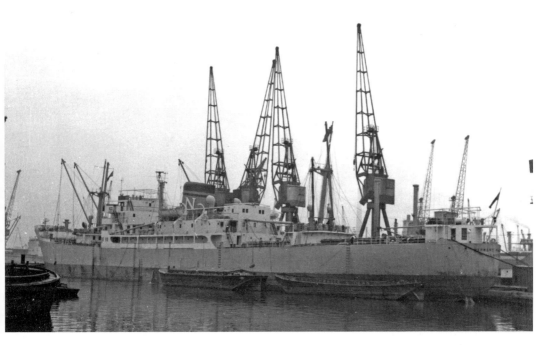

Named after an early exponent of African independence, the Nigerian MV *Herbert MacAulay* was built in 1957 and is in Tilbury on 29 March 1969.

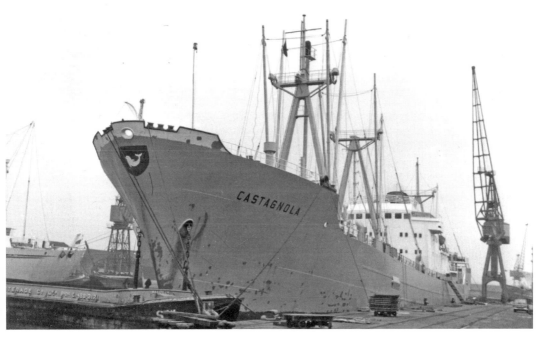

Despite being land-locked, Switzerland had some merchant ships. The MV *Castagnola* was built in Flensburg in 1961 and was broken up in 1984. Latterly she was named *Cuzco K*.

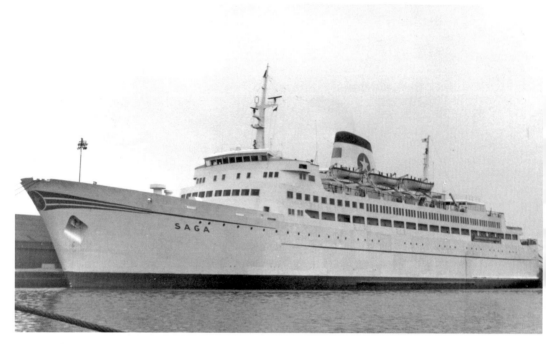

Berthed in Tilbury, rather than at the Stage as you would expect, is the Swedish MV *Saga* on 29 March 1969.

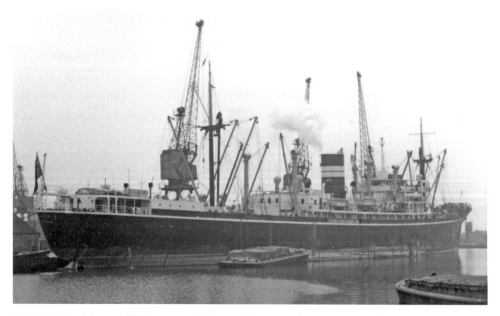

British India ships used Tilbury, as did those of P&O and Orient Line, all sister companies. BI was at one time the largest shipping fleet in Britain, despite many of their ships never sailing here, trading instead between India and Africa and Asia. Here is the MV *Chantala* of 1950 on 29 March 1969.

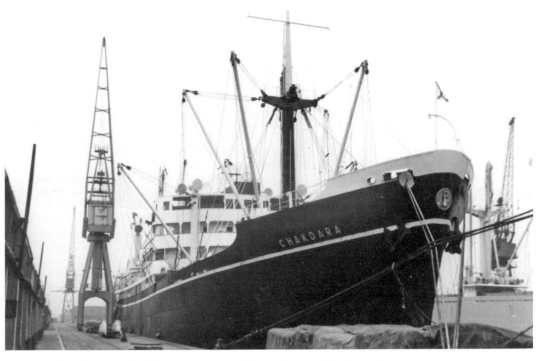

British India's MV *Chakdara* (7,132grt, built 1951) on 29 March 1969.

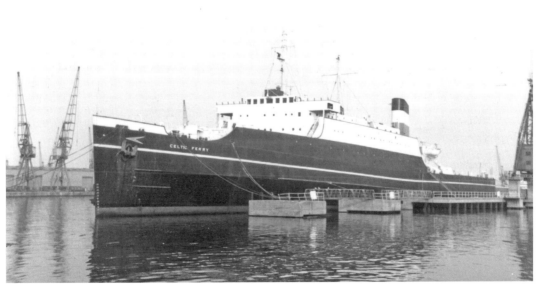

The Atlantic Steam Navigation Co.'s MV *Celtic Ferry* on 29 March 1969. The ASNC built the world's first roll-on roll-off ferries.

Sailing past the Palm Line's MV *Akassa Palm* (5,797grt, built 1958) is the tug *Napia* (261grt, built 1943) on 21 May 1969. Palm Line ceased trading in 1986 and primarily their ships sailed from British ports to West Africa from Morocco to Angola. *Akassa Palm* was broken up in 1984.

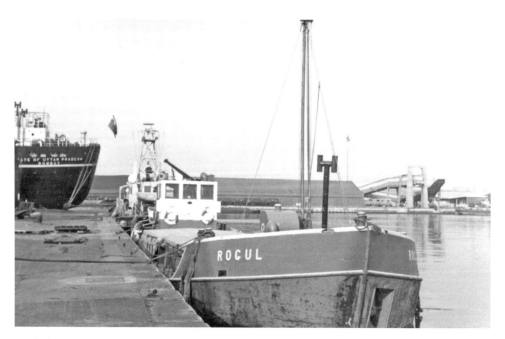

With the Indian vessel *State of Uttar Pradesh* behind, the small coaster *Rogul* (172 tons, built 1965) is berthed in Tilbury docks on 21 May 1969.

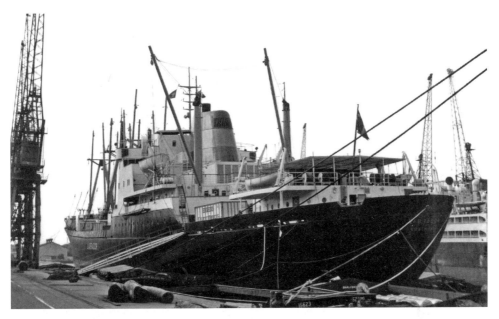

Registered in Copenhagen, the Danish cargo ship MV *Labrador* (4,430grt, built 1967) at Tilbury on 21 May 1969. Lighters surround her as she is being unloaded.

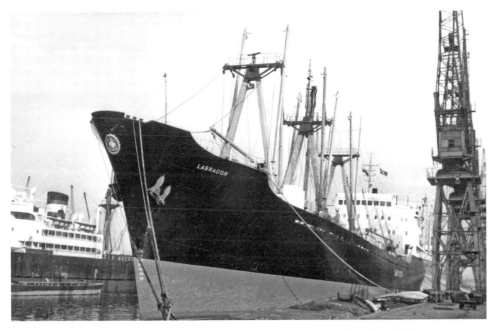

Riding high in the water, much of the *Labrador*'s cargo has been offloaded. Within a few years, containerisation would see the faster loading and unloading of many vessels.

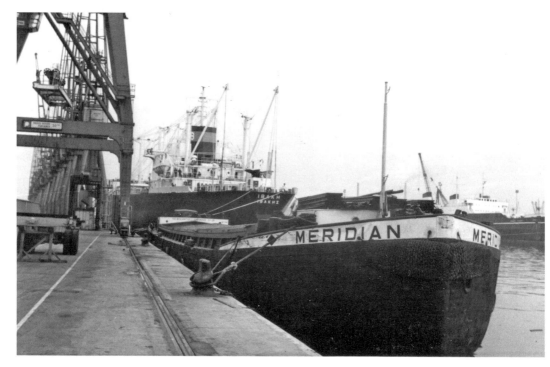

The *Meridian* was an ex-Rhine barge, which had been sold to British owners. Behind is the Greek MV *Ithaki* (9,066grt, built 1968) on 21 May 1969.

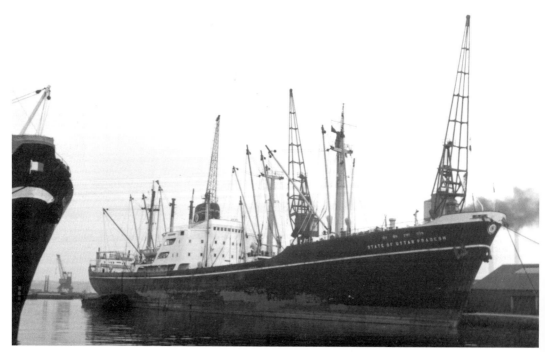

The Indian MV *State of Uttar Pradesh* (6,209grt, built 1960) at Tilbury on 21 May 1969.

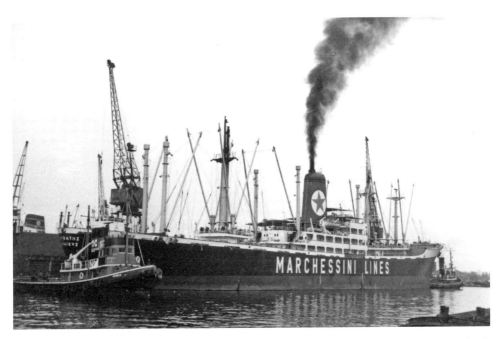

With steam up and ready to depart, the Greek Marchessini Lines SS *Eurybates* (6,373grt, built 1961) is being attended to by the tug *Ionia* at her stern and an unknown tug at her bow. Behind the *Eurybates* can be seen the funnel of the Indian vessel *State of Uttar Pradesh*.

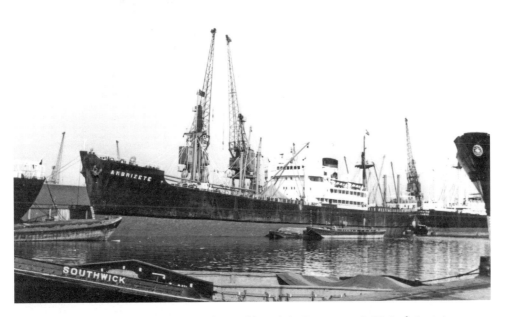

Tilbury would see ships from all over the world, and the Portuguese MV *Ambrizete* (5,503grt, built 1949) was in dock on 21 March 1969. Three other vessels and four lighters complete this busy scene.

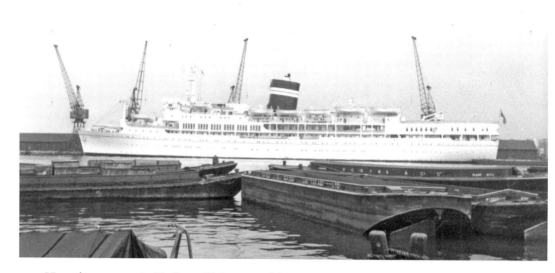

Viewed across a veritable fleet of lighters, used for transporting cargo around the dock system, is British India's SS *Uganda* on 21 May 1969. *Uganda* would distinguish herself as a troopship and hospital ship in the Falklands.

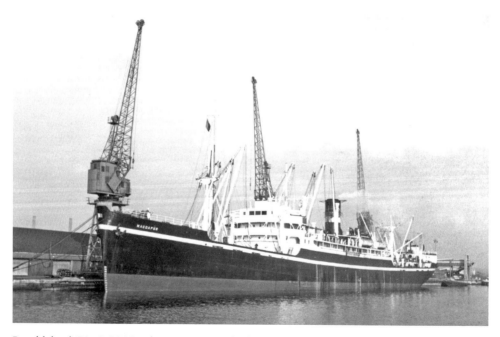

Brocklebank Line's SS *Magdapur* (8,364grt, built 1945) on 21 May 1969. The Brocklebank Line dates back to 1801 and was one of the oldest shipping lines in the world. Sixteen of its twenty-six ships were lost in World War Two and the line's last two ships were sold in 1983.

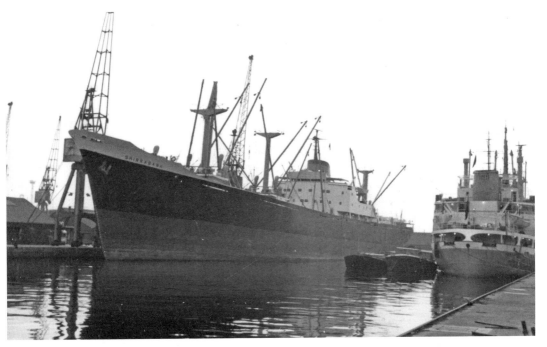

Built by Doxford in 1966, the 10,439grt *Shirrabank* was owned by the Glasgow-based Bank Line. Three years after entering service, she was photographed at Tilbury on 21 May 1969.

Photographed from between the legs of a giant dockside crane is the Swedish MV *Montevideo* (10,402grt, built 1958) on 7 July 1969.

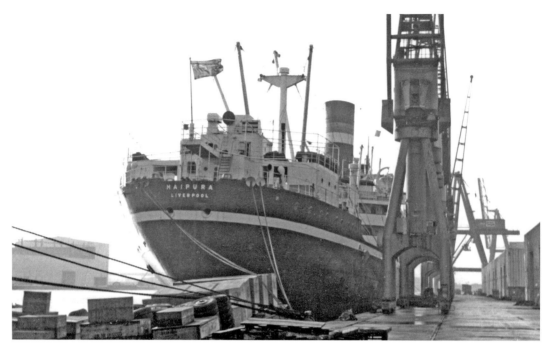

Flying her red duster is the Brocklebank liner SS *Maipura* (9,625grt, built 1952). Serving on the India route almost her entire career, she was sold in 1972.

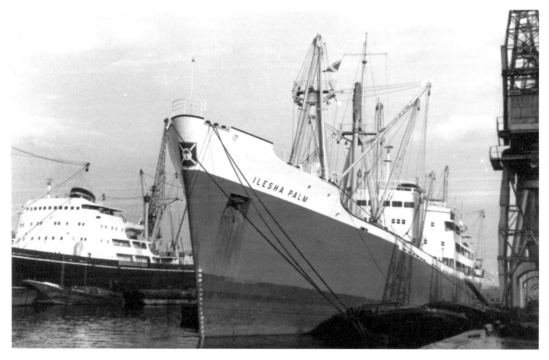

Palm Line's MV *Ilesha Palm* (5,682grt, built 1961) on 7 July 1969.

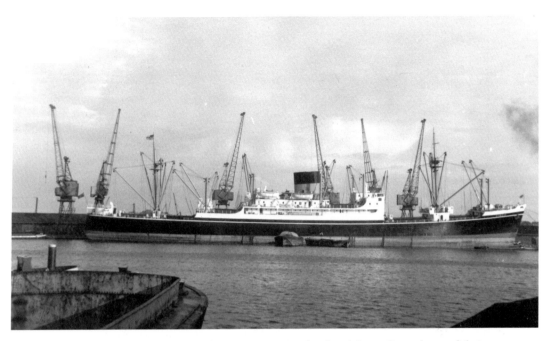

The Shaw Savill Line sailed from the UK to New Zealand and Australia and one of their most famous ships was the *Gothic*, which took Queen Elizabeth on a tour as far as Aden, by which time her royal yacht, *Britannia*, had been completed. Here, on 7 July 1969, is the 1953 MV *Cymric*.

With barrels waiting to be loaded from the lighter at her side, the Norwegian MV *Anna Presthus* (10,139grt, built 1958) could be found in Tilbury on 7 July 1969.

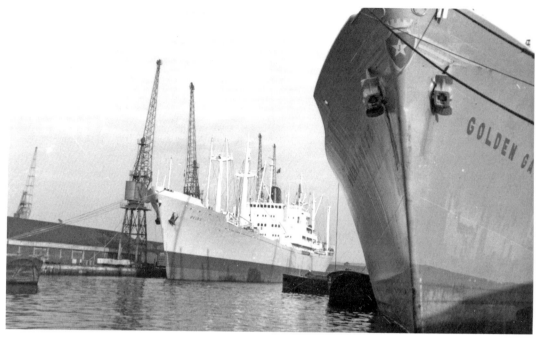

Looking down from the bow of the *Golden Gate* towards the Portuguese MV *Beira* (8,701grt, built 1963) on 7 July 1969.

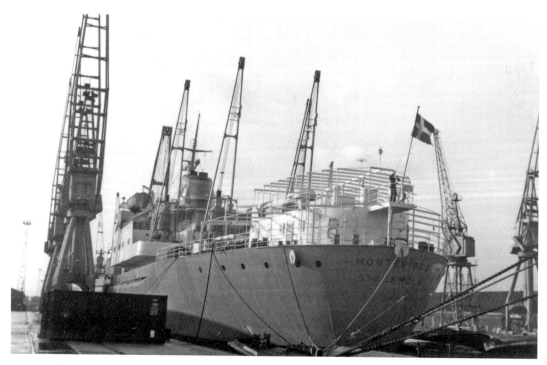

Another view of the Swedish MV *Montevideo* on 7 July 1969.

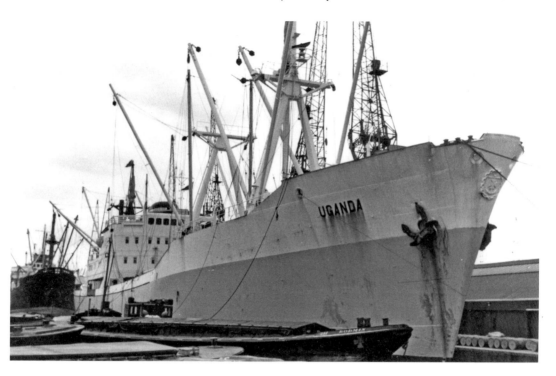

London was still the main port in the UK for the African steamers, despite Liverpool's former dominance in the trade. The Ugandan motor vessel *Uganda* (5,510grt, built 1958) is unloading barrels on 19 July 1969.

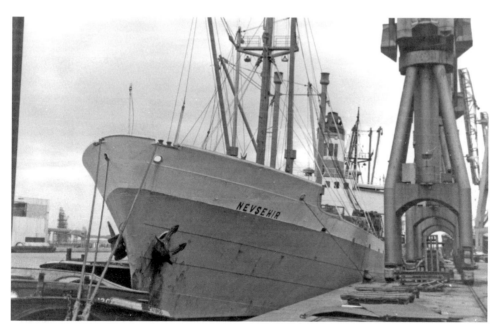

Turkey's SS *Nevsehir* (2,418grt, built 1952) on 19 July 1969.

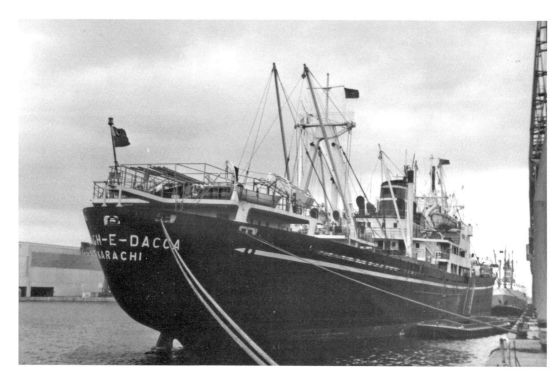

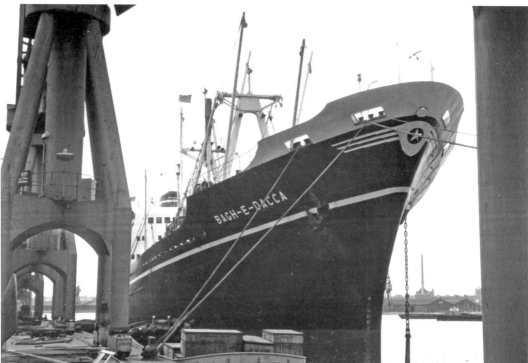

The Pakistani MV *Bagh-e-Dacca* (6,264grt, built 1966) was still a relatively new vessel on 19 July 1969.

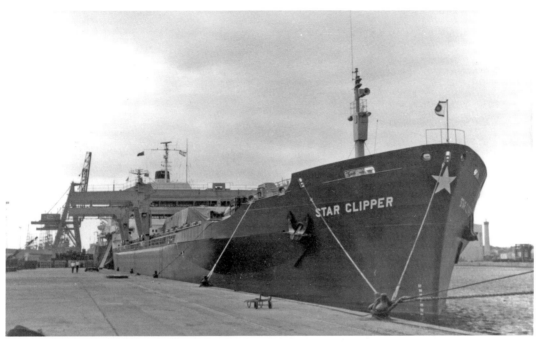

On 19 July 1969, the Norwegian bulk carrier MV *Star Clipper* (18,470grt, built 1968) was in Tilbury. Note the huge cranes on her decks.

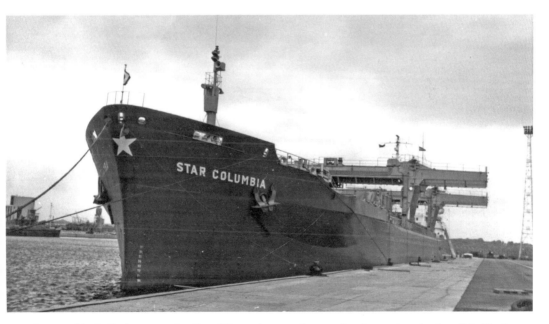

Scrapped in India in 1986, the *Star Clipper* is most famous for destroying the Swedish Almö Bridge on 18 January 1980. She collided with the 1960-built bridge in fog at 1.30 a.m., causing it to collapse. Eight people in seven vehicles that plunged into the sea died before the bridge could be closed. Her sister ship *Star Columbia* is shown here.

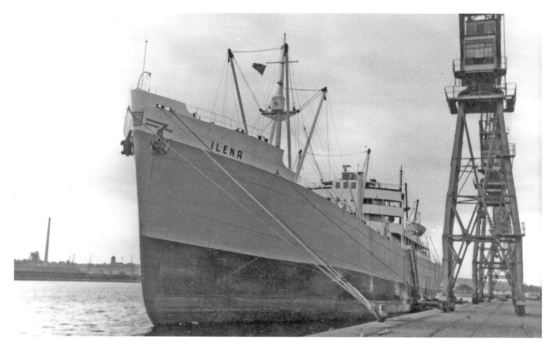

The Lebanese MV *Ilena* (5,925grt, built 1937) on 19 July 1969.

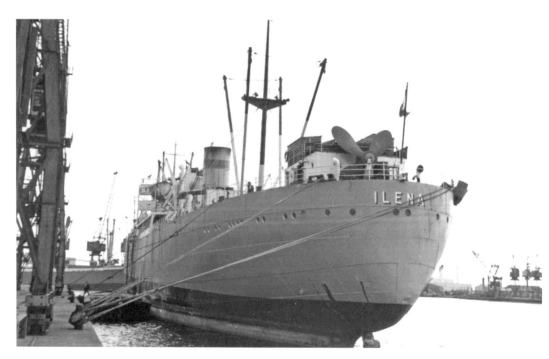

A stern view of the *Ilena*, showing her spare propeller mounted on dock. With a three–six month casting and machining time, a ship could ill afford to lose a propeller, and to this day many ships still carry a spare.

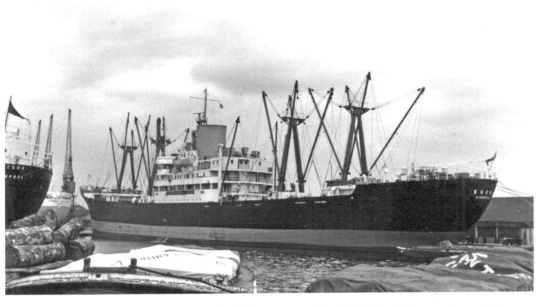

Scott's of Greenock's yard no. 673, the Elder Dempster Line's MV *Egori* (8,331grt) on 19 July 1969. Built in 1957, the Liverpool-registered ship was scrapped in 1978.

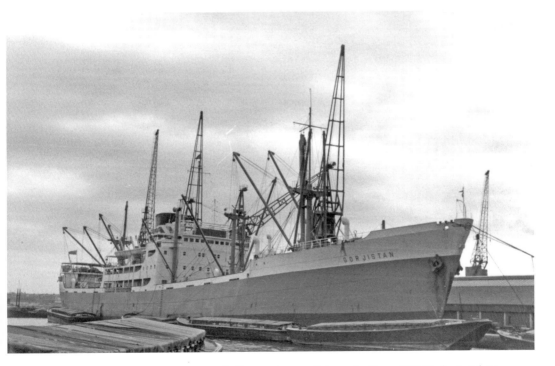

Strick Line's MV *Gorjistan* (9,449grt, built 1961) on 19 July 1969. Part of P&O, the Strick Line operated primariliy in the Gulf and Mediterranean.

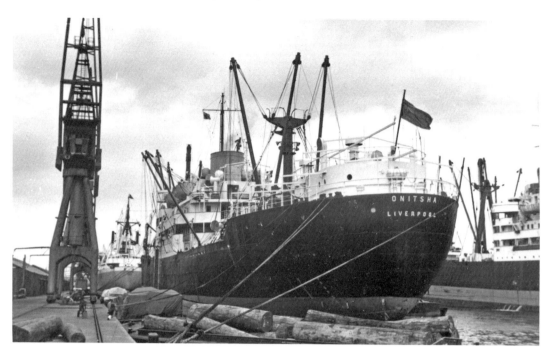

Elder Dempster's MV *Onitsha* (7,267grt, built 1952) and her sister *Obuasi* could be found on the route to Nigeria. Here, she is photographed at Tilbury on 19 July 1969.

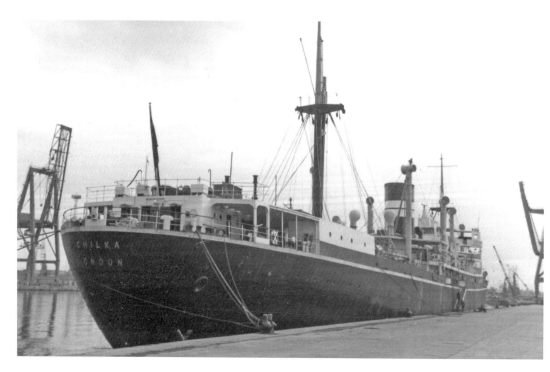

British India Steam Navigation Co.'s MV *Chilka* (7,087grt, built 1950) on 26 October 1969.

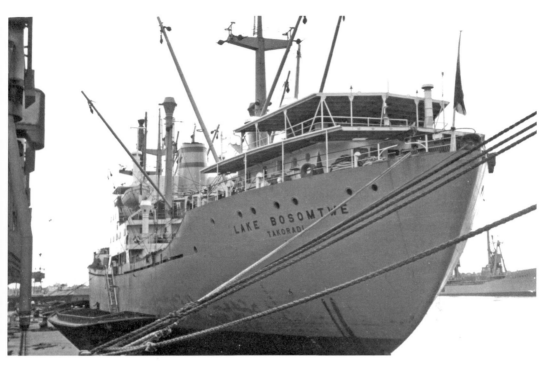

The Ghanaian MV *Lake Bosomtwe* (7,356grt, built 1963) at Tilbury on 26 October 1969.

From the bow of the *Algor*, in view are the Ellerman Line's MV *City of St Albans* and the Swedish Lloyd MV *Saga* on 26 October 1969.

Built at Swan Hunter's on the Tyne, British India's *Chilka* was broken up in India in 1972

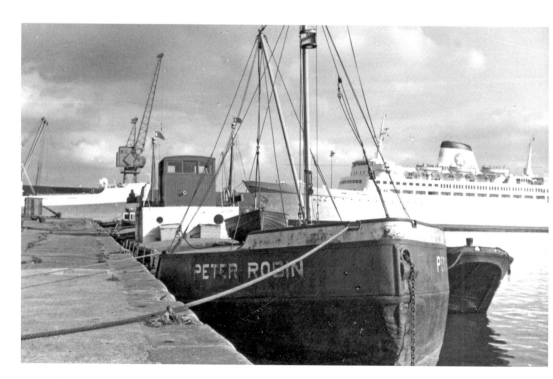

The coaster MV *Peter Robin* (156grt, built 1916), with the MV *Saga* astern on 26 October 1969.

With the sailing barge *Cabby* (96grt, built 1928) berthed next to an unknown barge, the gleaming *Saga* is shown behind on 26 October 1969.

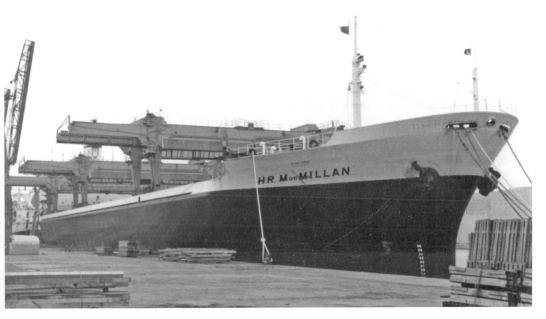

The bulk carrier *H.R. MacMillan* (21,461grt, built 1968) was barely a year old on 22 February 1970.

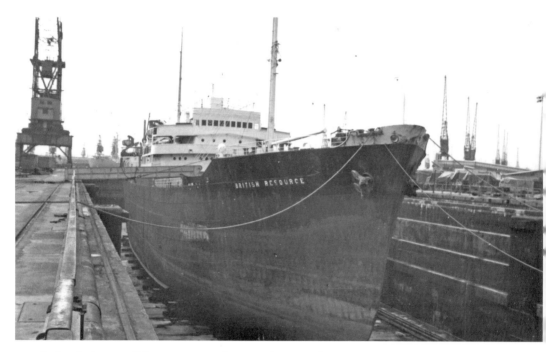

In dry dock on 22 February 1970 is the BP tanker *British Resource* (11,200grt, built 1949).

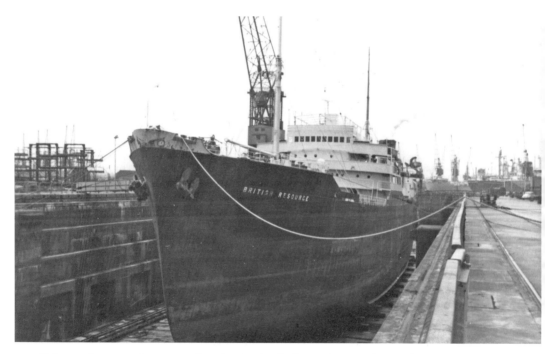

Ship repair was an important function in the docks, and many ships, which had either been damaged or had broken down would go into the dry dock for repair. Some ships could be overhauled here too.

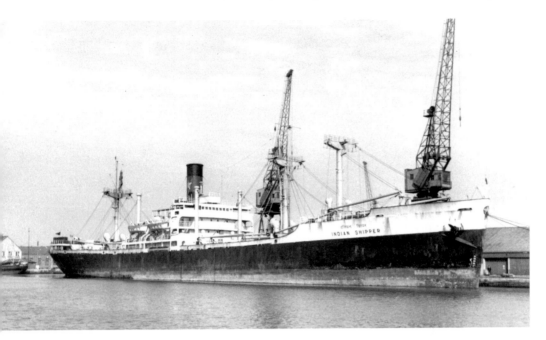

Built in 1944, the SS *Indian Shipper* was laid down as the *United States Victory* and sold to India in 1947. She was scrapped a year after this view was taken in 1971 in Taiwan.

Built in 1955 and photographed on 15 March 1970, the Greek MV *Rio Doro* (7,790grt) at Tilbury. Deals of wood fill the lighter at her side. On charter to British India Steam Navigation Co., despite her grey hull, she sports BI funnel colours.

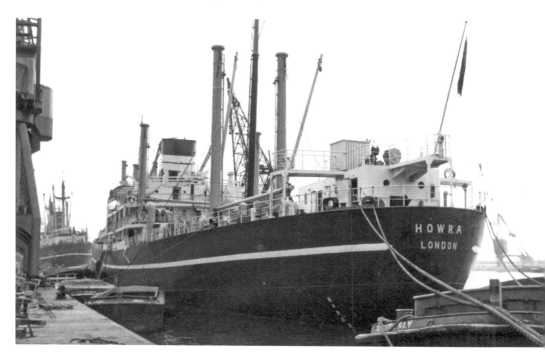

BI's MV *Howra* (6,194grt, built 1952) on 15 March 1970. She was originally Avenue Steam Ship Co.'s MV *Limerick* but was transferred to BI in 1969 and sold in 1972 to Singapore as the *Golden Haven*.

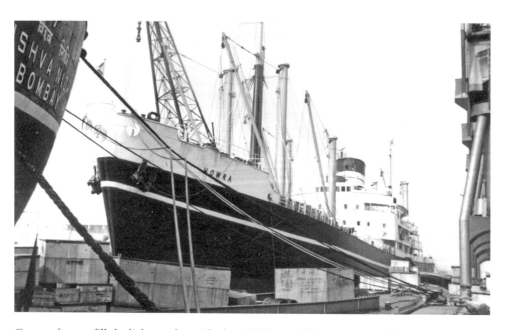

Crates of cargo fill the lighters alongside the MV *Howra*. This was a very labour intensive way of moving cargo, as well as likely to cause damage, and it is easy to see how containers soon took over from the older forms of moving goods.

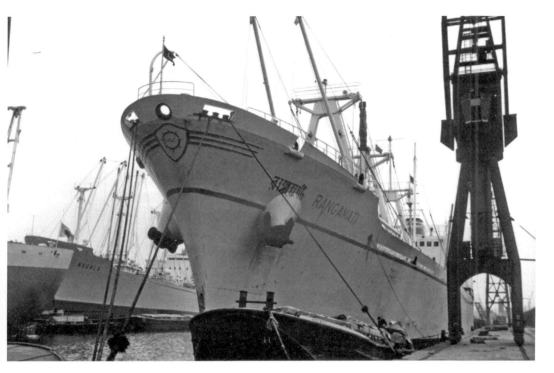

Pakistan's MV *Rangamati* (8,909grt, built 1968) at Tilbury on 15 March 1970. The lighter *Brewer* is at her port side and starboard is the *Nagala*.

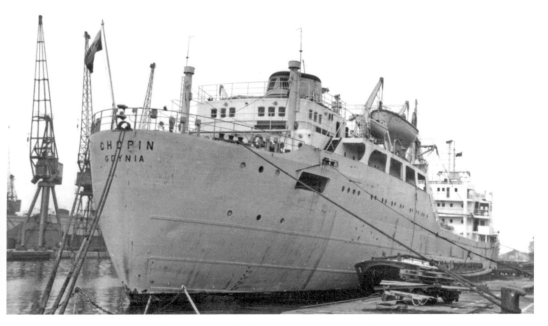

The Polish MV *Chopin*, of Gydnia, was built in 1959 and is shown here on 15 March 1970.

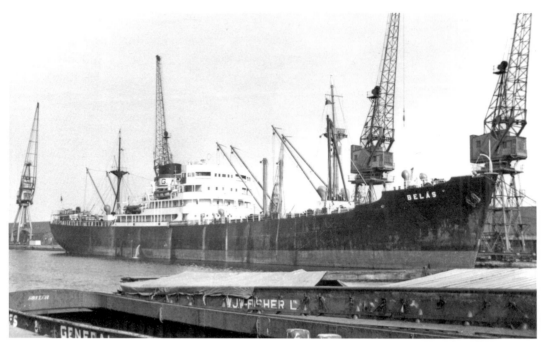

Portugal's MV *Belas* (4,448grt, built 1949) was owned by the Soc. Geral de Com. Ind. Transportes and built at Doxford's. She is here on 15 March 1970.

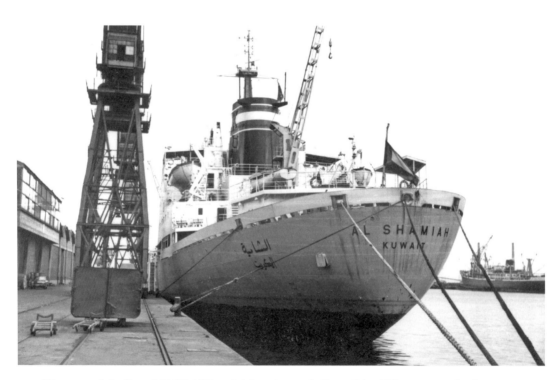

The stern of the Kuwaiti MV *Al Shamiah* (11,670grt, built 1968) at Tilbury on 21 April 1974.

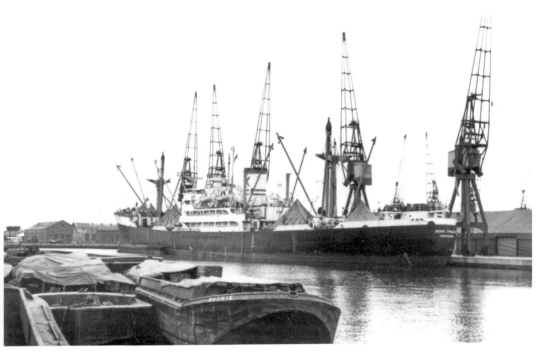

Tilbury, 21 April 1974. The Cypriot MV *Aghia Thalassini* (8,120grt, built 1954) is viewed from next to a sea of lighters, including the *Buckie*.

Entering the docks and getting ready to berth is the West German MV *Comar II* (1,000grt, built 1971) on 21 April 1974.

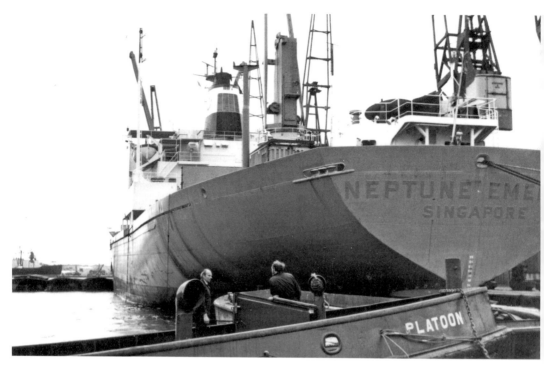

Aboard a lighter, two dock workers chat while the stern of the MV *Neptune Emerald* (12,463grt, built 1973) towers above them on 21 April 1974.

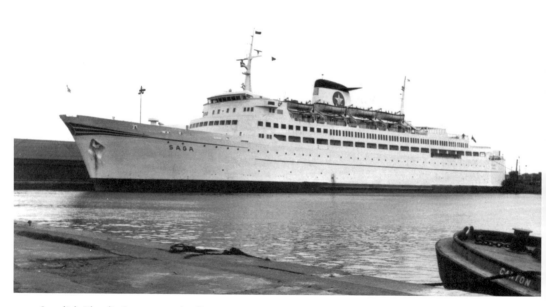

Swedish Lloyd's *Saga* on 21 April 1974.

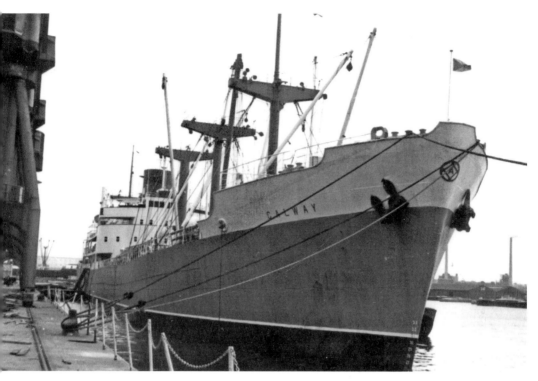

Avenue Steam Ship Co.'s MV *Galway* was built in 1959 and is shown here on 22 June 1974.

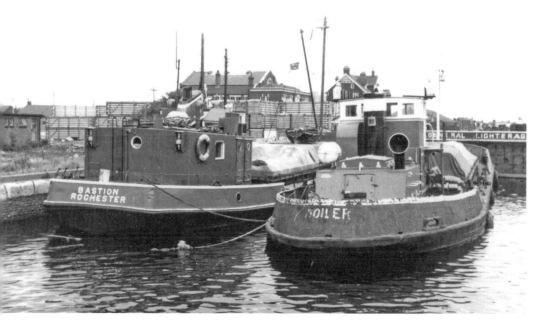

Bastion of Rochester (172grt, built 1958) and the *Moiler* (138grt, built 1915) on 3 August 1974.

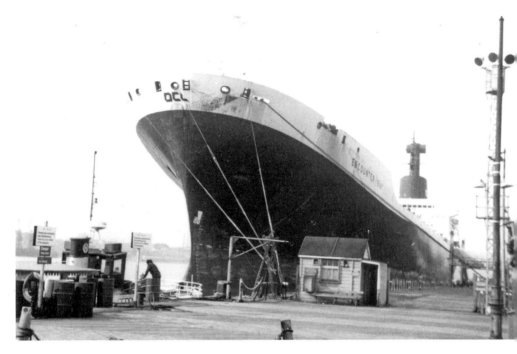

Times were a changing and the container ship MV *Encounter Bay* opened the Australia/UK container route in March 1969. Overseas Container Line was a consortium of four British shipping companies that had begun the company to start making the expensive transition from the old forms of shipping cargo to the more sensible containerisation. All the OCL ships had a green hull with white topping.

Chapter Three

On the River

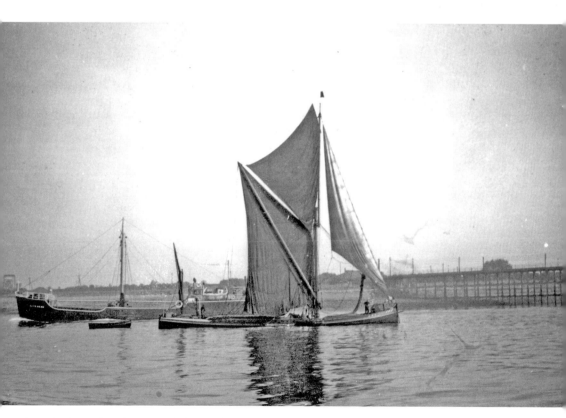

Amazingly, within the span of this book, we have gone from sailing barges to container ships, from ocean liners to ferries and from general cargo ships to state-of-the-art specialised cargo vessels. Here, on 13 August 1949, the spritsail barge *Joy* (56 tons, built 1914) and the motorship *Rosedene* (376grt, built 1938) pass each other.

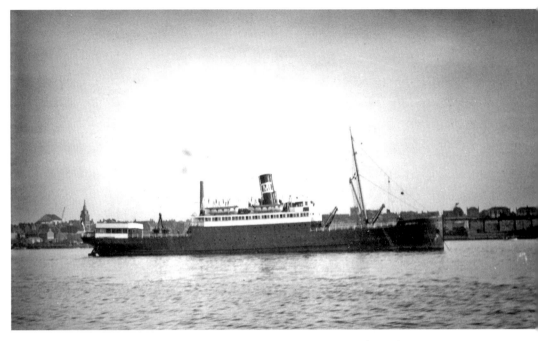

The Dutch steamer *Batavier II* (1,726grt, built 1921) in Gravesend Reach, 13 August 1949.

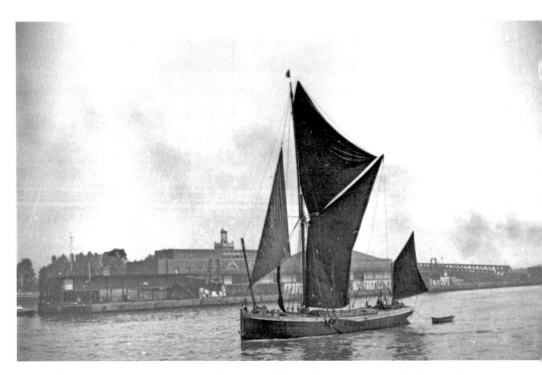

Off the Stage on 21 August 1955 is the spritsail barge *Memory* (65 tons, built 1904).

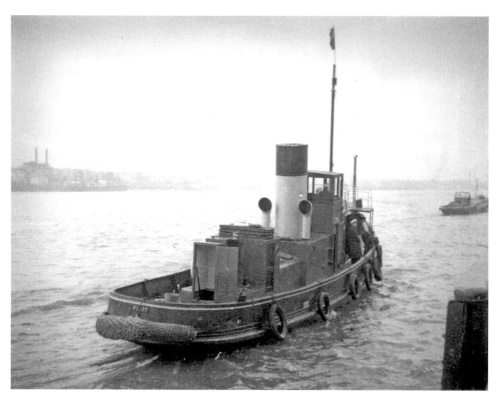

Photographed from the Stage is the tug *Pilot* on 11 September 1956.

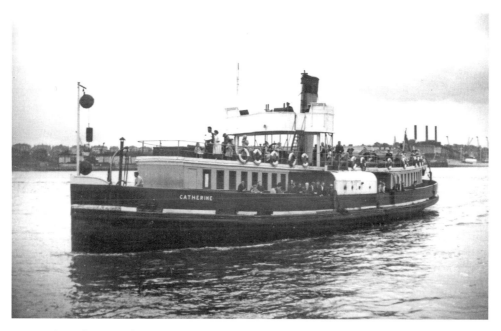

Approaching the Stage from Gravesend on 14 August 1960 is the ferry *Catherine*, built in 1903.

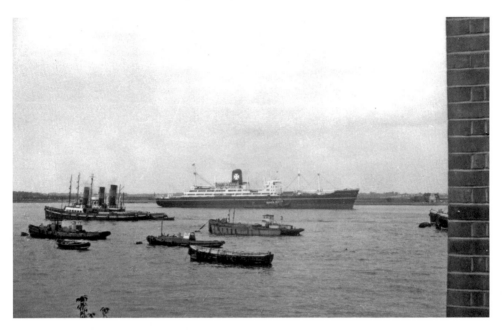

Houlder Bros SS *Royston Grange* (10,262grt, built 1959) passing Gravesend, 12 August 1961. On 11 May 1972, tragedy struck the *Royston Grange* when she collided wit a Liberian tanker, the *Tien Chee*, in the Punta Indio Channel in the River Plate. Seventy-four crew and passengers were on board and all were killed in the resulting fire. Eight of the *Tien Chee*'s crew died too but the rest abandoned ship and were rescued.

The Danish MV *Nordglimt* (7,053grt, built 1956) off Gravesend on 12 August 1961. A tug awaits the call to duty at the pier.

Passing a BP tanker on 26 August 1963 is the Nigerian MV *Nnamdi Azikiwe* (6,063grt built 1963). Behind, the port is crammed with cargo ships of all sorts and sizes.

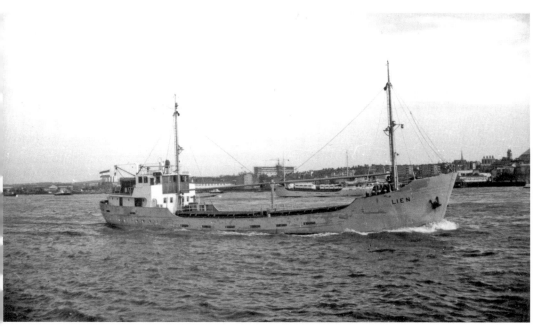

The Dutch coaster MV *Lien* (386grt, built 1957) passing Tilbury and heading back to the sea on 12 May 1964.

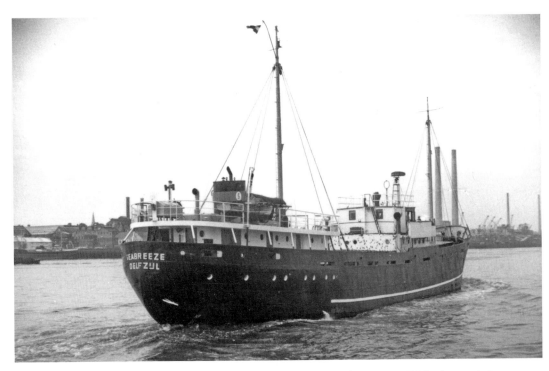

With the towers of Tilbury A power station ahead, the Dutch coaster MV *Seabreeze* (489grt, built 1964) passes Tilbury and heads for the sea.

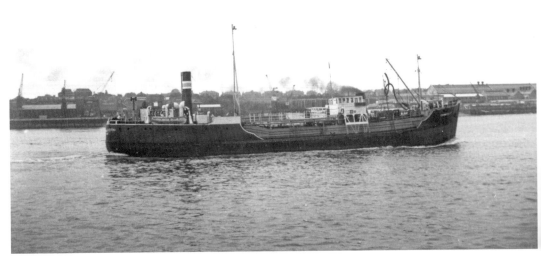

The steam tanker *Commodity* (470grt, built 1943) off Tilbury on 29 July 1964.

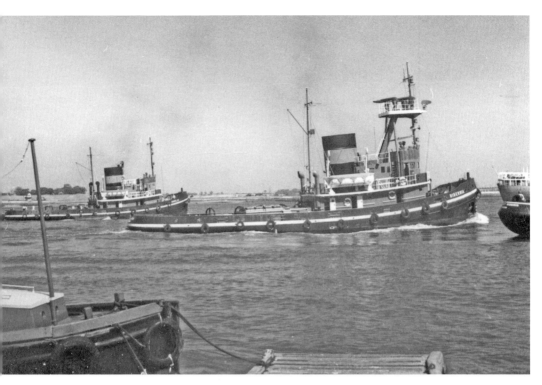

The tugs *Dhulia* and *Hibernia* head down river on 26 August 1964.

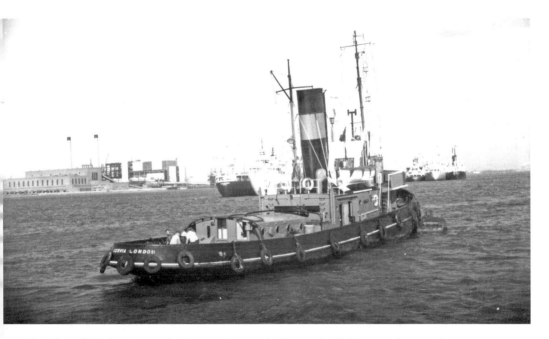

Another of Watkins' tugs, the *Cervia* (233grt, built 1946) off Gravesend on 29 August 1964. Behind is Tilbury power station and a veritable fleet of ships tied up in mid-river.

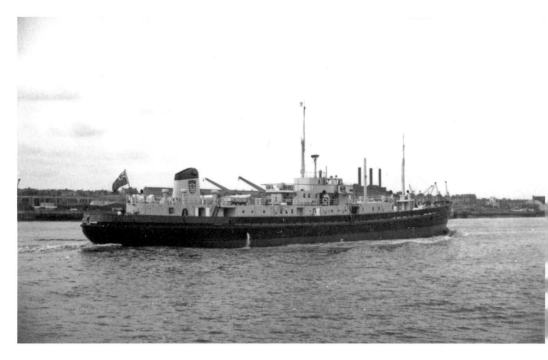

The sludge vessel *Sir Joseph Rawlinson* (2,258grt, built 1964) would take sewage out to the lower Thames and dump it far from land. She was brand new when this view was taken on 29 July 1964 and on 28 September 1965 she was lost after a collision with the *Danube VIII* in the estuary.

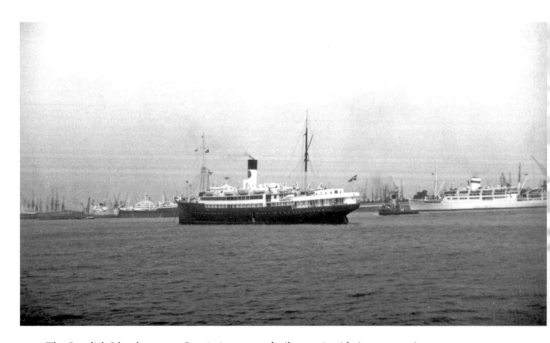

The Swedish Lloyd steamer *Suecia* (4,695grt, built 1929) mid-river on 11 August 1964.

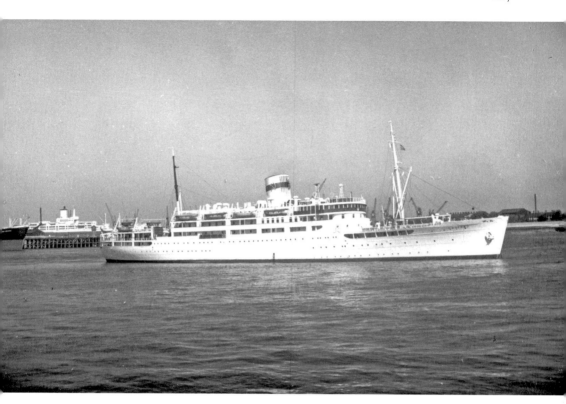

With an Orient liner in the docks, the *Baltika* heads down river on 26 August 1964.

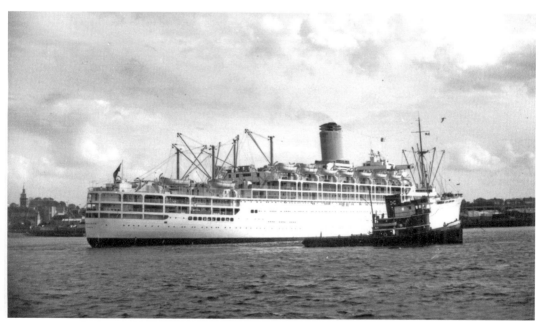

P&O's SS *Himalaya* has set sail from Tilbury docks and is heading down river on 26 June 1965.

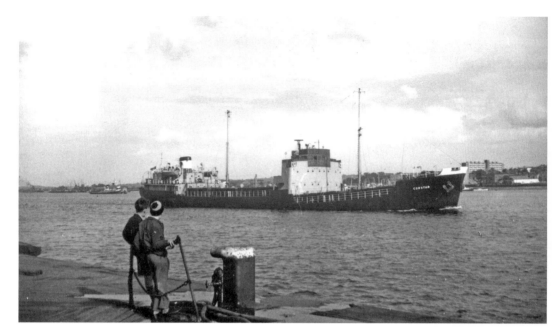

Two young boys watch from the Stage as the tanker *Corstar* (3,379grt, built 1956) passes Tilbury on 26 June 1965.

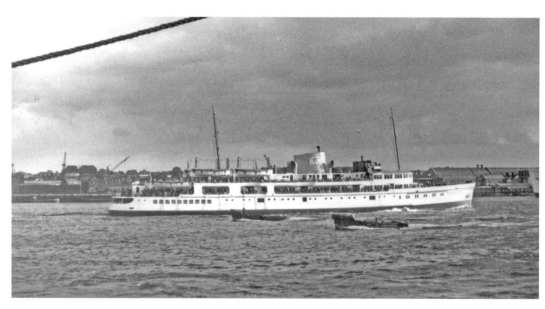

A common sight on the river were the pleasure steamers of the General Steam Navigation Company. The *Royal Sovereign* of 1948 could be seen anywhere on the river from Tower Pier and the Pool to Southend, Ramsgate and Margate. Passing Tilbury on 26 June 1965, she had barely two years to go before being sold. Her career was long, however, as she was sold to become a truck ferry in 1967 and survived until 2007 in Italy until being driven ashore at Aliaga, Turkey, and scrapped.

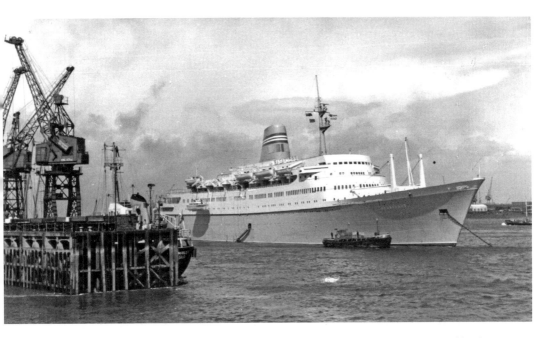

The Norwegian American liner MV *Sagafjord* off Gravesend on 6 May 1966. One of her boats is about to be lowered.

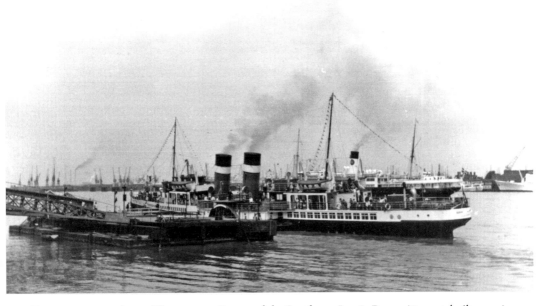

For two seasons the paddle steamer *Queen of the South*, ex-*Jeanie Deans* (839grt, built 1931), plied her trade on the Thames. She was ultimately unsuccessful and was scrapped after a poor 1967 season. On 11 June 1966, she was calling at Gravesend to pick up passengers for a trip down river.

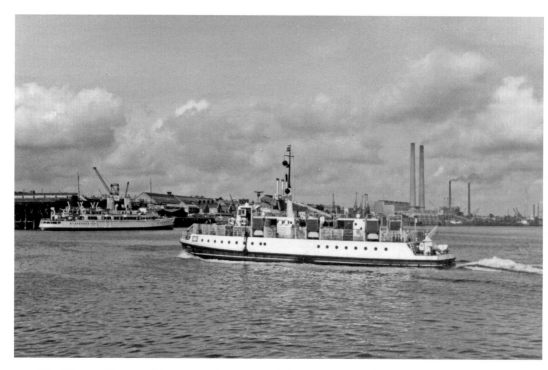

The Tilbury–Gravesend ferry on 18 June 1966. A GSNC steamer is berthed across the river from the ferry. The double-arrow logo was introduced in 1965.

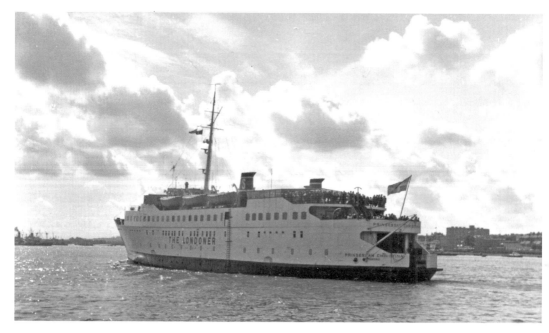

Prinsessan Christina sails from Tilbury on 'The Londoner' cross-channel service on 18 June 1966.

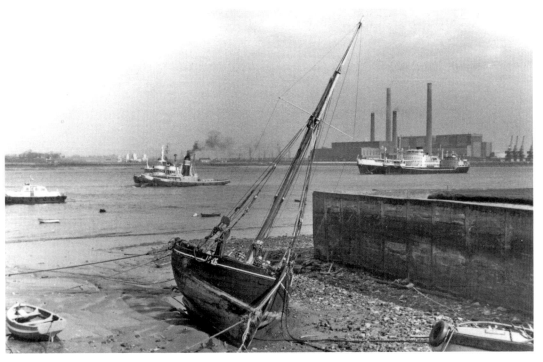

Ships at Gravesend, 3 March 1967. In view are two tugs, a fishing boat and on the right, the Greek MV *Nymphe* (8,251grt, built 1954) and the MV *Rogate* (4,995grt, built 1967).

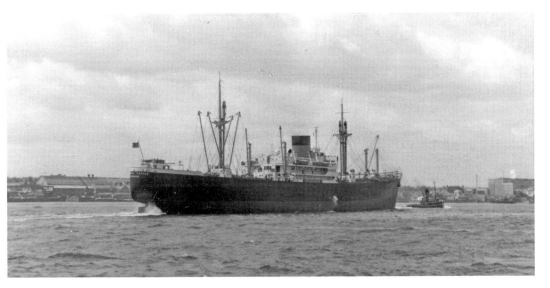

Tintagel Castle was built at Belfast for the Union-Castle Line in 1954 and her maiden voyage to South Africa was on 11 June 1954. She was one of the cargo liners on the East Africa route and lasted with Union-Castle until 1971. In June 1971, she was sold to the Armar Shipping Co. of Cyprus and renamed *Armar*. On 27 June 1978 she reached Kaohsiung, Taiwan, for breaking. She is here off Tilbury on 21 June 1967.

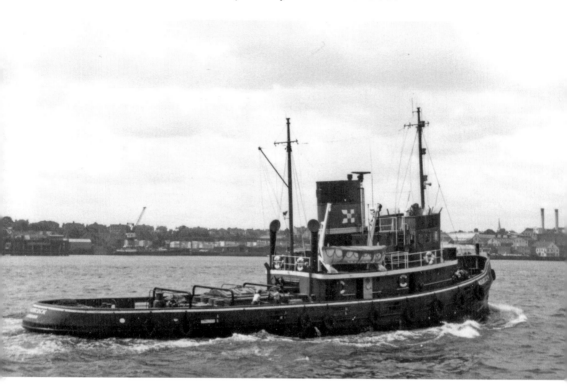

The tug *Moorcock* off Tilbury on 21 June 1967.

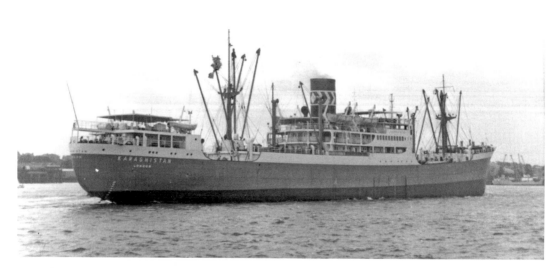

The Strick Line MV *Karaghistan* (7,440grt, built 1957) in the river on 22 June 1967.

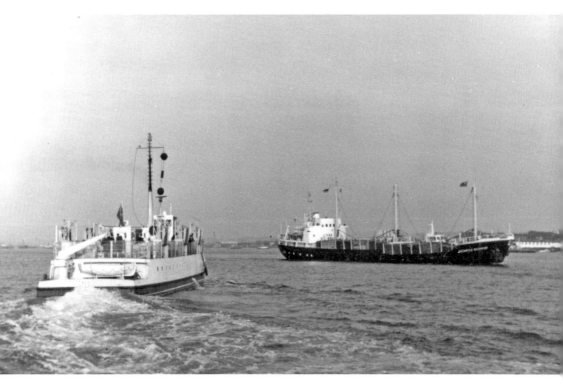

A Tilbury–Gravesend ferry speeds across the river, ready to cross behind the German MV *Heinrich Schmidt* (1,292grt, built 1963) on 1 July 1967.

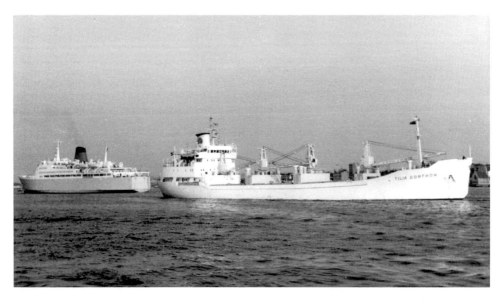

The Ellerman Wilson Line MV *Sperro* heads upriver as the Swedish MV *Tilia Gorthon* heads downriver on 1 July 1967. Ordinarily used on the Hull–Gothenburg route, the *Sperro* is deputising for *Svea* or *Saga* on the Tilbury route. She was scrapped at Alang in 2005.

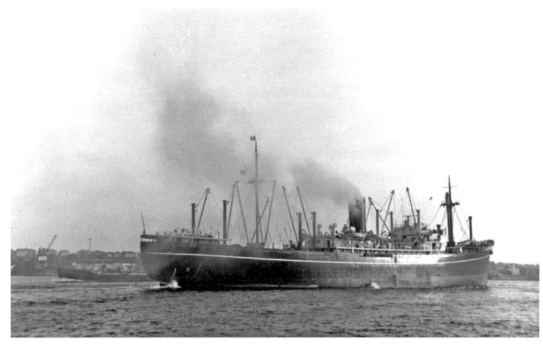

P&O's cargo ship SS *Sunda* (9,235grt, built 1952) heads to the London docks on 1 July 1967. *Sunda* was built by John Brown's at Clydebank and made her maiden voyage to the Far East in October 1952. She was one of six 'Singapore-class' vessels.

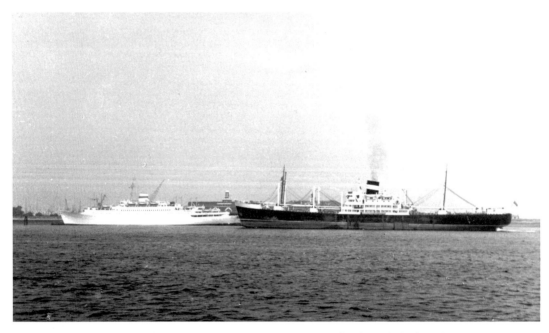

British India's *Cornwall* is passing the East German MV *Volkerfreundschaft* at the Stage on 28 August 1967. Within a few days *Cornwall* had changed her name to *Juna*.

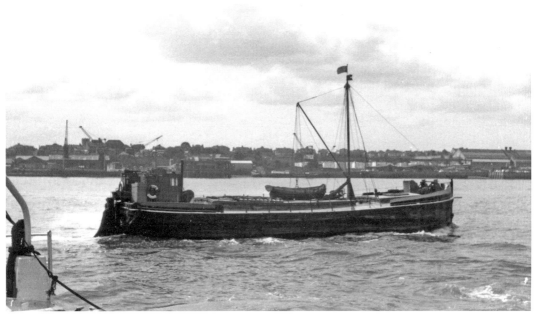

The MV *Cabby* (96 tons, built 1928) off Tilbury, 30 August 1967.

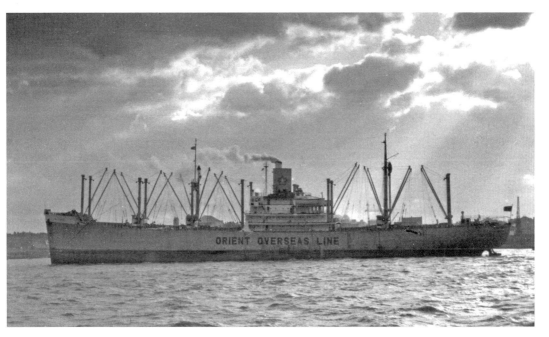

Orient Overseas Line's *E-Yung* (8,149grt, built 1943) at dusk off Tilbury on 17 January 1968. Now one of the world's largest container shipping lines, and known as OOCL, OCL's founder C.Y. Tung purchased Cunard's *Queen Elizabeth* to convert her to a floating university. Just as she was being completed, she was destroyed by fire in Hong Kong harbour.

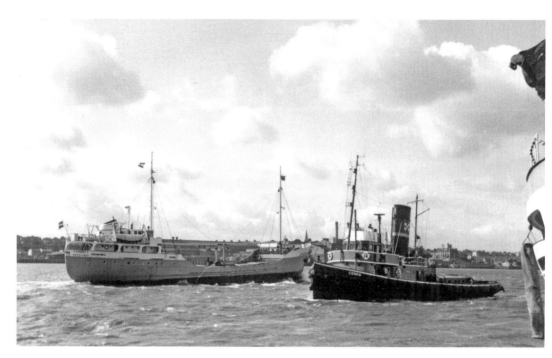

Passing the Dutch coaster MV *Carebeka* (500grt, built 1957) is the tug *Cervia* (233grt, built 1946) on 21 September 1968.

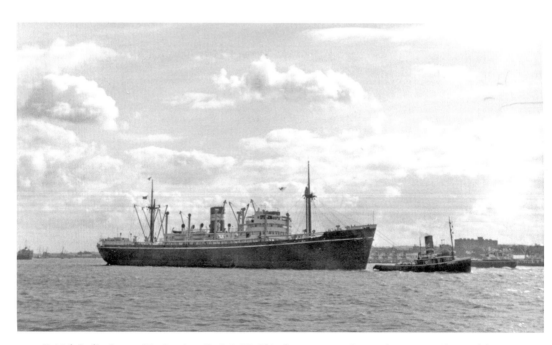

British India Steam Navigation Co.'s MV *Chindwara* on 21 September 1968. She could carry twelve passengers but was primarily a cargo vessel. In 1971, she was sold to Pacific International Lines of Singapore and renamed *Kota Aman*. In 1974, she was scrapped.

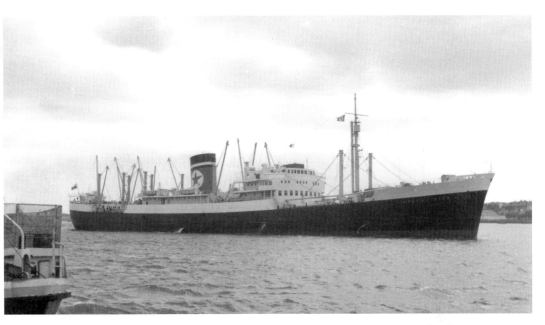

Blue Star Line's MV *Imperial Star* (13,181grt, built 1948) heading upriver off Tilbury on 19 July 1968. She was built by Harland & Wolff in Glasgow for the Union Cold Storage Co. and managed by Blue Star. In 1965, she transferred to Blue Star and was sold in 1971 to Taiwan for breaking, with work commencing on 10 December that year. By mid-1971, she had been totally cut down and scrapped.

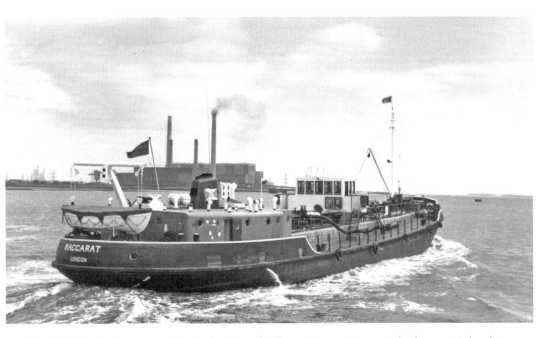

Used for bunkering cargo ships in the Port of Tilbury, *Baccarat* (293grt, built 1959) is heading back down river on 19 July 1969.

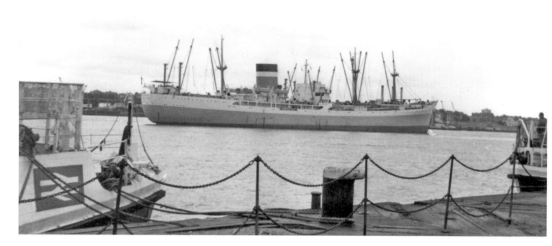

The Ellerman Line's *City of Cape Town* (9,914grt, built 1959) off Tilbury on 1 September 1969.

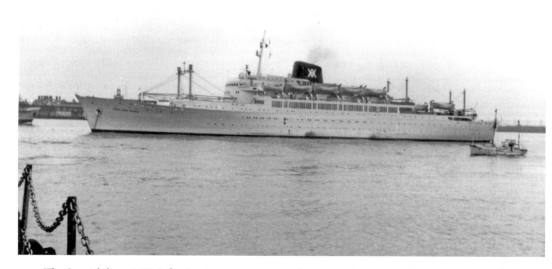

The Spanish liner MV *Cabo San Roque* (14,491grt, built 1957) was owned by Ybarra, and often used on the Genoa–Buenos Aires route. She was a rare sight in London and is shown here off Gravesend on 20 August 1970. In 1973 she made cruises to Antarctica and was scrapped in 1985.

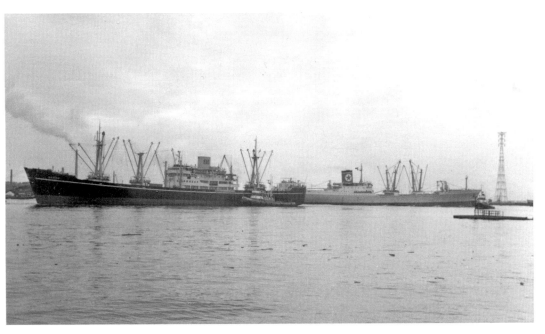

The Danish East Asiatic Co.'s MV *Samoa* (6,239grt, built 1953) and the Blue Star Line's MV *Southland Star* (11,300grt, built 1967) off Tilbury on 26 October 1969. In 1977, *Southland Star* was converted to a cargo ship in Vegesack, Germany, and was scrapped in 1993 in Chittagong, Pakistan.

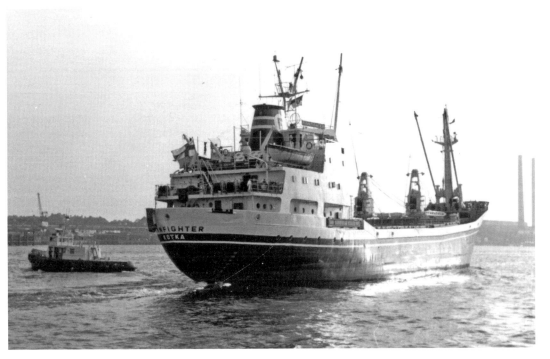

Sailing down river is the Finnish MV *Finnfighter* (2,727grt, built 1965) on 3 June 1971.

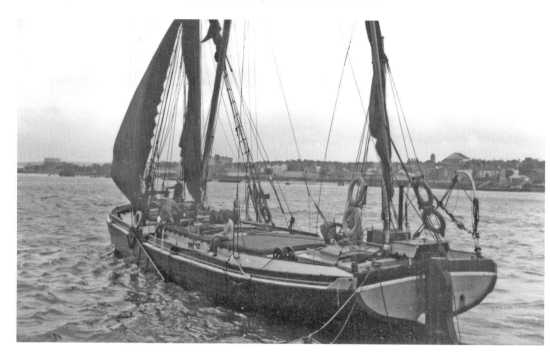

The sailing barge *Lord Roberts* (79 tons, built 1900) on 26 May 1972. *Lord Roberts* was built at the height of the Boer War in Maldon, Essex, at Cook's Barge Yard for Meeson's of Battlesbridge. She still sails today.

Heading up river is the motor tanker *Chartsman* (787grt, built 1967) while the tug *Sun XIX* (192grt, built 1956) awaits her next customer on 26 May 1972.

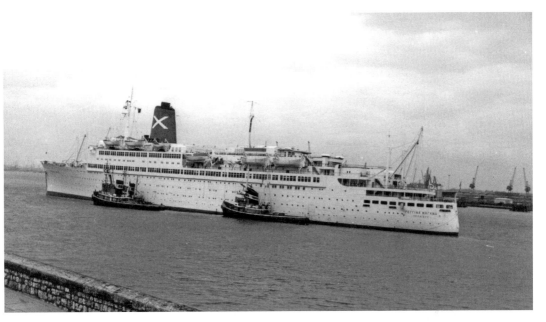

Escorted by two tugs, the Chandris Line's *Regina Magna* (32,360grt, built 1938) off Gravesend on 23 June 1972. Sunk on the way to the breakers in 1980, *Regina Magna* had begun her life as the *Pasteur*, before being sold to Hamburg Amerika Line as the *Bremen*. Purchased by Chandris in 1971, she was laid up in 1974 and used as an accommodation ship in Saudi Arabia before being sold for breaking.

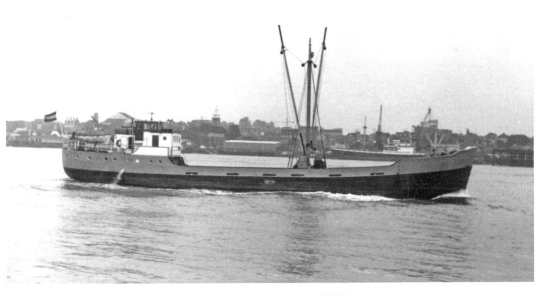

The Dutch coaster MV *Hondsboch* (217grt, built 1947) off Tilbury on 30 August 1973.

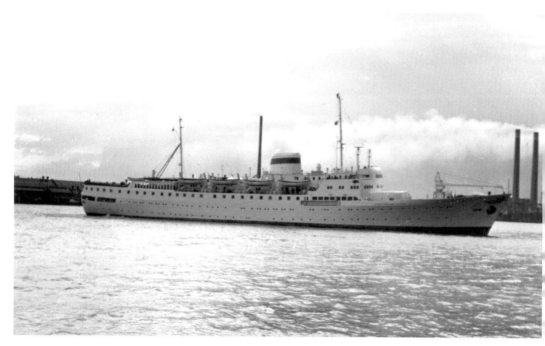

The Russian passenger ship MV *Litva* (5,035grt, built 1960) off Tilbury on 11 October 1975.

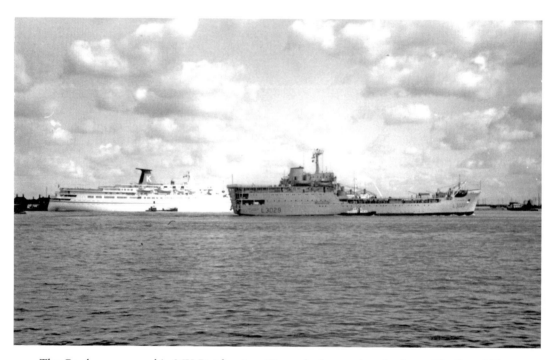

The Greek passenger ship MV *Daphne* (11,683grt, built 1955) at the Stage. The Royal Fleet Auxiliary's *Sir Galahad* (6,390grt, built 1964) is mid-river. *Sir Galahad* was destroyed by bombs during the Falklands War and was sunk on 21 June 1982 and is now an official war grave.

The Norwegian MV *Vistafjord* sails past the *Sir Galahad* on 5 September 1976.

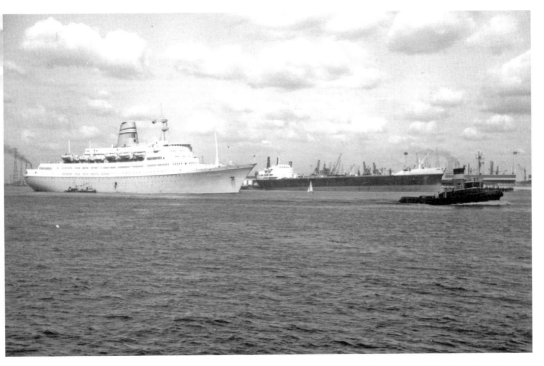

Berthed at Tilbury Landing Stage is the tanker *Drupa* (39,796grt, built 1965), while *Vistafjord* is being bunkered mid-river.

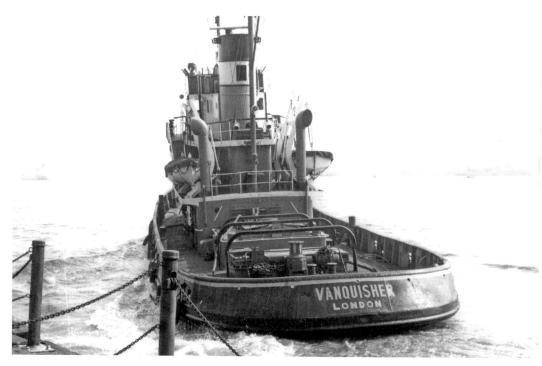

Pulling away from the Stage is the tug *Vanquisher* (294grt, built 1955) on 12 September 1976.

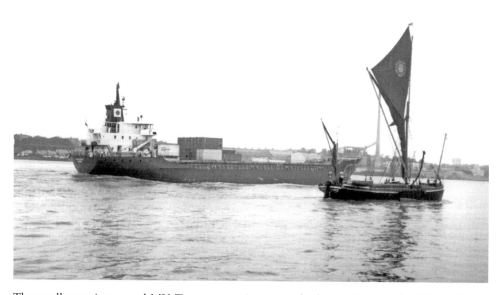

The small container vessel MV *Towerstream* (1,599grt, built 1975) passes the Thames barge *Gladys* (87 tons, built 1901) on 12 July 1977. This scene contrasts seven decades of Thames shipping, from the sailing barges that could once be found in every creek and jetty on the river and the container ships that would revolutionise shipping the world over.

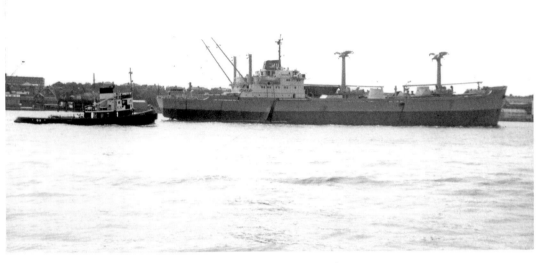

P&O's *Strathdyce* (9,230grt, built 1977) off Tilbury on 30 july 1977.

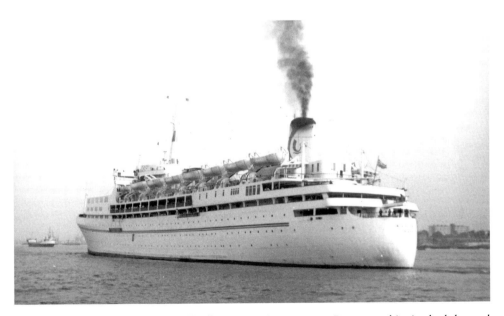

The *Calypso* (ex-*Southern Cross*) off Tilbury on 31 August 1979. Passenger shipping had changed too, and now cruise ships, disgorging holidaymakers, have replaced the passenger vessels that once called at ports the world over, taking emigrants to new lives. Of course, one must not forget the *Empire Windrush*, which brought to Tilbury 493 immigrants from the Caribbean in 1948, the first of many post-war.

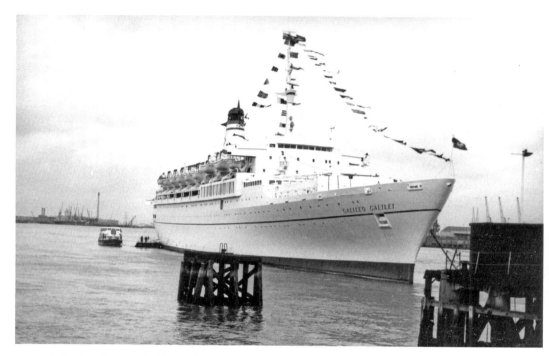

The Italian liner SS *Galileo Galilei* (27,907grt, built 1963) on 27 July 1980. As *Sun Vista*, after an engine room fire, the ship sank on 21 May 1999. All 1,090 passengers and crew abandoned ship and were rescued.

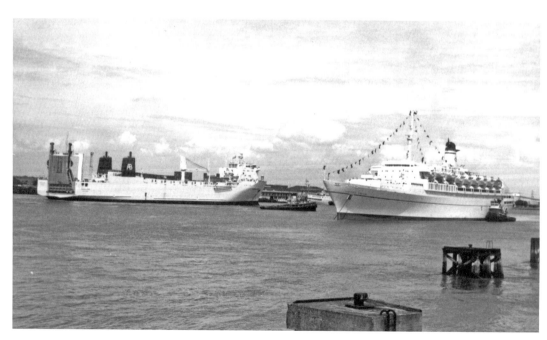

The Swedish MV *Vasaland* (9,386grt, built 1979) and the *Galileo Galilei* dressed overall off Gravesend on 27 July 1980.

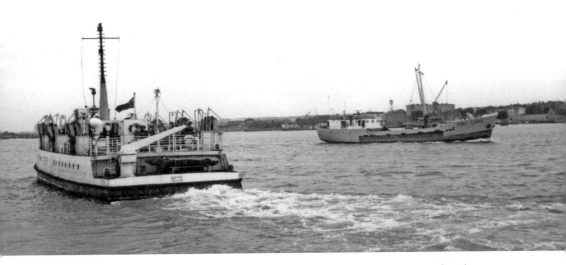

Tilbury stage from Gravesend, with a ferry leaving a cruise ship at the terminal and a cargo vessel heading up river.

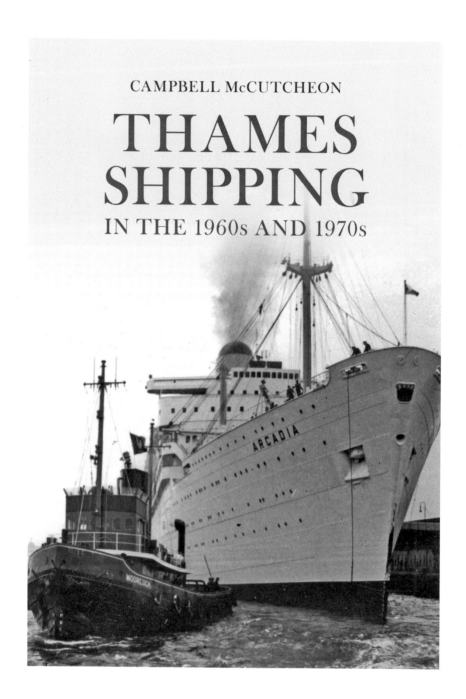

CAMPBELL McCUTCHEON

THAMES SHIPPING

IN THE 1960s AND 1970s

Available from all good bookshops or to order direct
Please call **01453–847–800**
www.amberleybooks.com